Cobourg Ontario Book 3 in Colour Photos, Saving Our History One Photo at a Time

Photography by Barbara Raué
©2019

Series Name: Cruising Ontario

Book 227: Cobourg Book 3

Cover photo: 110 Ontario Street, Page 46

©All the photos in this book have been taken with my cameras. I own the rights to them.

Series Name: Cruising Ontario
Saving Our History One Photo at a Time
in colour photos

Books Available in Alphabetical Order:
Aberfoyle, Acton, Ajax, Alton, Amherstburg, Ancaster, Arthur, Auburn, Aylmer, Ayr, Beaver Valley, Belgrave, Belleville, Bloomingdale, Blyth, Brantford, Brockville, Burford, Burlington, Caledon, Caledonia, Cambridge, Carlow, Chatsworth, Clifford, Collingwood, Conestogo, Delhi, Dorchester to Aylmer, Drayton, Drumbo, Dundas, Dunlop, Eden Mills, Elmira, Elora, Erin, Essex, Fergus, Goderich, Grimsby, Guelph, Hagersville, Hamilton, Hanover, Harriston, Hespeler, Jarvis, Kingston, Kingsville, Kitchener, Lake Superior, Lincoln, Linwood, Listowel, London, Lucknow, Merrickville, Mono, Mount Forest, Mount Pleasant, Neustadt, New Hamburg, Newboro, Newport, Niagara-on-the-Lake, Niagara Falls, North Bay, Oakville, Onondaga, Orangeville, Orillia, Oshawa, Owen Sound, Palmerston, Paris, Pelham, Perth, Peterborough, Petrolia, Pickering, Port Colborne, Port Elgin, Portland, Preston, Rockwood, Sarnia, Sault Ste. Marie, Seaforth, Sheffield, Shelburne, Simcoe, Smiths Falls, Smithville, Southampton, St. Catharines, St. George, St. Jacobs, St. Marys, St. Thomas, Stoney Creek, Stratford, Thamesford, Thunder Bay, Tillsonburg, Toronto, Waterdown, Waterford, Waterloo, Welland, Wellesley, West Flamborough, Westport, Whitby, Windsor, Wingham, Woodstock

Book 212-215 Haldimand County
Book 216: Sudbury
Book 217: Parry Sound
Book 218-219: Uxbridge
Book 220: Port Perry

Book 221-222: Stouffville
Book 223: Colborne
Book 224: Grafton, Bolton
Book 225-230: Cobourg

Table of Contents

Hibernia Street	Page 5
Orr Street	Page 7
Durham Street	Page 15
Sydenham Street	Page 19
Bagot Street	Page 24
Ontario Street	Page 34
Tweed Street	Page 47
Alice Street	Page 52
Tremaine Street	Page 53
Stuart Street	Page 58
Queen Street	Page 61
Green Street	Page 65

Cobourg is a town in Southern Ontario ninety-five kilometers (59 miles) east of Toronto and 62 kilometers (39 miles) east of Oshawa. It is located along Highway 401. To the south, Cobourg borders Lake Ontario.

The settlements that make up today's Cobourg were founded by United Empire Loyalists in 1798. The Town was originally a group of smaller villages such as Amherst and Hardscrabble, which were later named Hamilton. In 1808 it became the district town for the Newcastle District. It was renamed Cobourg in 1818, in recognition of the marriage of Princess Charlotte Augusta of Wales to Prince Leopold of Saxe-Coburg-Saalfeld (who later become King of Belgium).

By the 1830s Cobourg had become a regional center, much due to its fine harbor on Lake Ontario. In 1835 the Upper Canada Academy was established in Cobourg by Egerton Ryerson and the Wesleyan Conference of Bishops. On July 1, 1837, Cobourg was officially incorporated as a town. In 1841 the Upper Canada Academy's name was changed to Victoria College. In 1842 Victoria College was granted powers to confer degrees.

Cobourg retains its small-town atmosphere, in part due to the downtown and surrounding residential area's status as a Heritage Conservation District. The downtown is a well-preserved example of a traditional small-town main street. Victoria Hall, the town hall completed in 1860, is a National Historic Site of Canada. The oldest building in the town is now open as the Sifton-Cook Heritage Centre and operated by the Cobourg Museum Foundation.

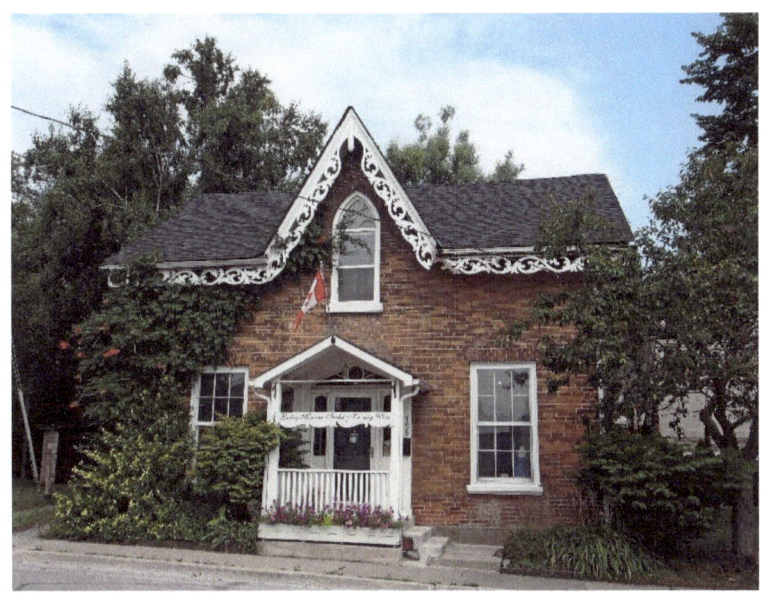

158 Hibernia Street – 1858 – Ontario Vernacular – verge board trim on gable and along roof cornice

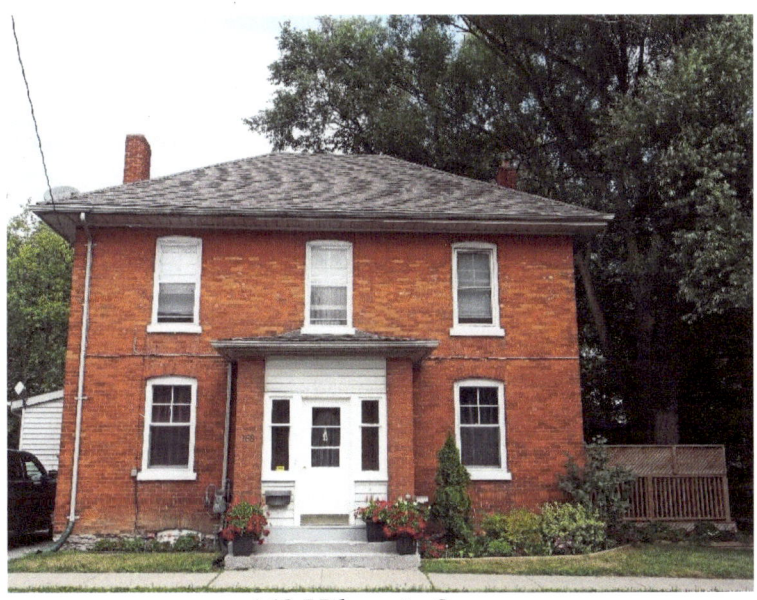

168 Hibernia Street

169 Hibernia Street

173 Hibernia Street

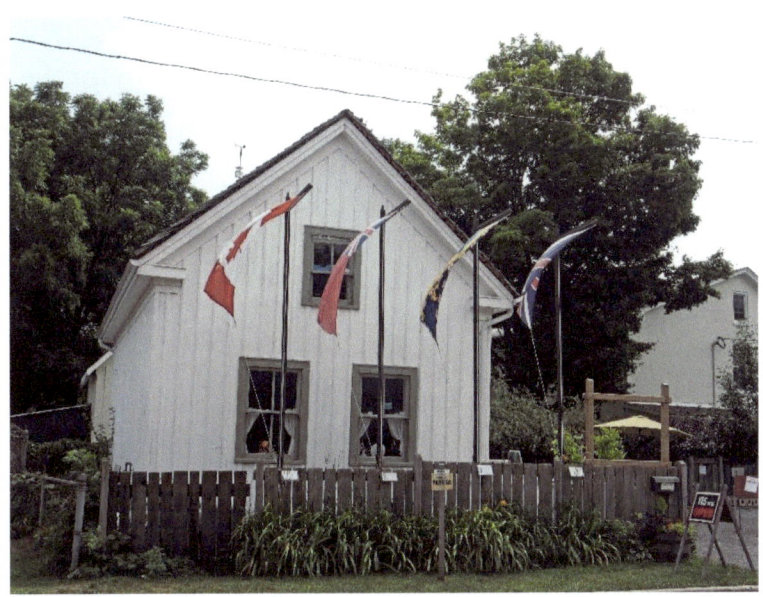

141 Orr Street – The Cobourg Museum Foundation and The Sifton-Cook Heritage Centre – The Barracks – 1814-1820

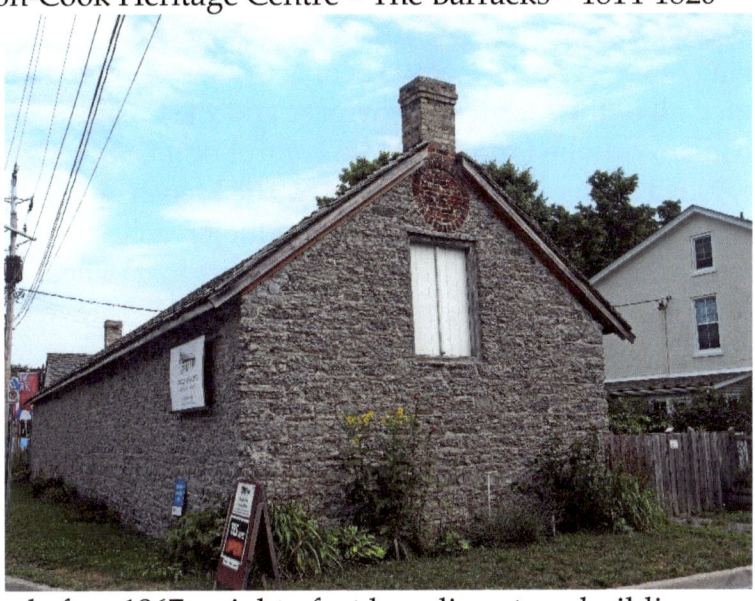

Circa before 1867 – eighty feet long limestone building – one tradition says it was built as a military barracks with the threat from the Americans during the War of 1812

The history of the flags of Canada – Canada's first flag was a variation of a flag used to identify British ships at sea. In February 1965, the new Maple Leaf Flag was flown for the first time.

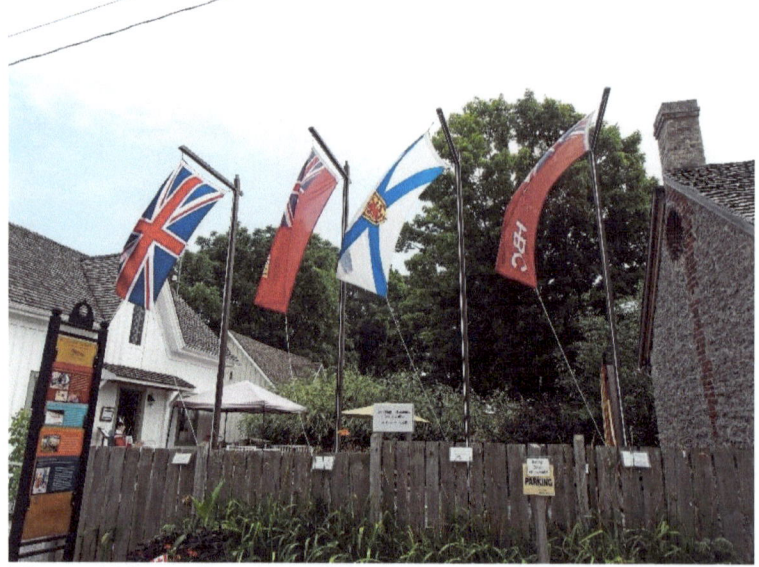

The Flag of Nova Scotia – Nova Scotia, or New Scotland, one included all of the Maritime provinces and the Gaspe Peninsula. With the French fully in control of the St. Lawrence River, Nova Scotia was fought over by the French and the English for 150 years until the defeat of the French and the fall of New France in 1760. Of the four provinces that joined together in Confederation, only Nova Scotia had its own flag. With a blue diagonal cross on a white field, the flag is the reverse of the flag of St. Andrew, the patron saint of Scotland. The gold shield with a red lion rampant is the Royal Arms of Scotland.

In 1868, Queen Victoria gave a coat-of-arms to the four provinces that joined to form the Dominion. This first Canadian flag was based on the British naval Red Ensign with the arms of the four provinces joined together in a shield.

The Red Ensign is the last of six versions which existed since 1868 to the adoption of the Maple Leaf flag in 1965. It pays tribute to the early settlers of Canada by displaying their arms in the crest on the lower right. Clockwise from the top left they represent England, Scotland, France and Ireland.

The King's Colours, became the Flag of Britain in 1603 after James I became king of both England and Scotland. It combined the flag of St. George of England (a red horizontal cross on a white field) superimposed on that of St. Andrew of Scotland (a white diagonal cross on a blue field. The United Empire Loyalists adopted this flag as they supported the British against the Americans and resettled in Canada. Official use came to an end in 1801 when the addition of Ireland created the United Kingdom of Great Britain. The diagonal red cross of Saint Patrick on a white field was added to create the Union Jack.

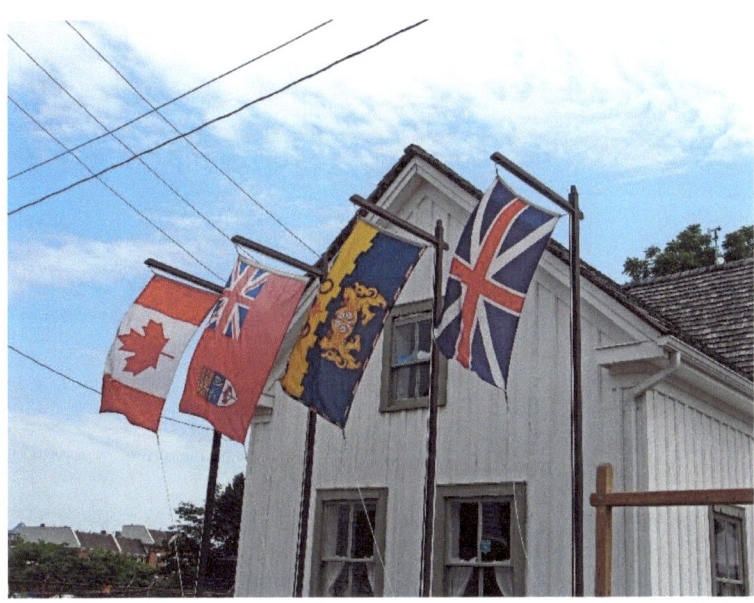

The Flag of the Hudson's Bay Company – By Royal Charter in 1760, the Hudson's Bay Company acquired trading rights to more than half the land of Canada. HBC extended its system of trading forts as far south as California. Its responsibilities included maintaining order and administering justice. Three years after Confederation, the HBC sold Rupert's Land to the Dominion. With the decline of the fur trade, HBC turned to selling retail goods to settlers. By the end of WWI, it had a fleet of 300 ocean-going freighters and was a principle supplier of war materials to France. The flag has a red ensign in the upper left corner on a red field with white letters HBC in the bottom right.

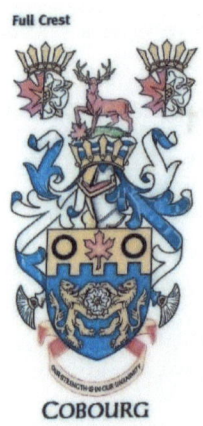
COBOURG

The flag of Cobourg – Settlers adopted the name Cobourg in celebration of the 1818 marriage of an English Duke and a German princess who became the parents of the future Queen Victoria. The full crest of Cobourg combines elements found in the crest of the German principality of Saxe-Coburg-Saalfeld, the Royal Arms of England, the Ontario Crest, and the red Maple Leaf. The flag was designed when Cobourg was founded and incorporated elements of the crest including the two English lions embracing the white rose of Saxe-Coburg-Saalfeld.

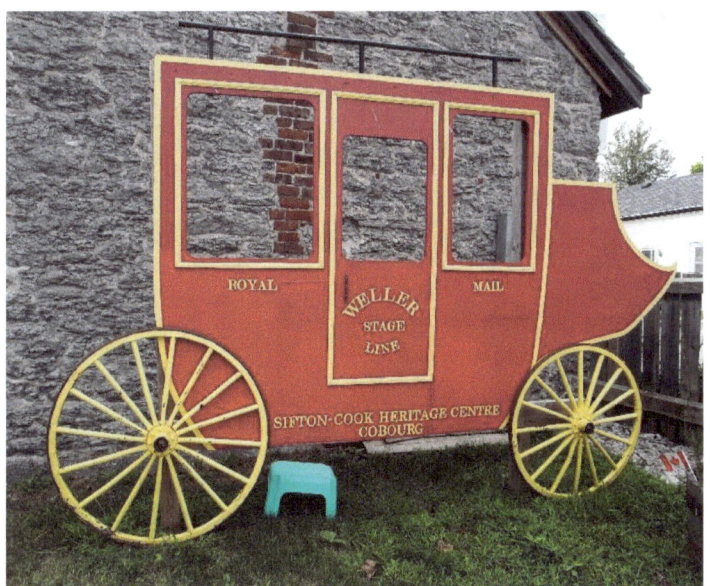

The Weller Stage Coach Company – William Weller's coach lines served the growing communities along the St. Lawrence River and Lake Ontario – the lakeshore often referred to as the Front. He extended the service to the developing townships and villages, such as Peterborough, north of the front. Public transportation over land was essential for them as contact with the Front was essential because an isolated town couldn't live or thrive. When the proprietor moved his operation from Toronto to Cobourg in the 1840s, Cobourg enjoyed new benefits. Coaches were built in a Weller shop at George and Orange Streets and were of very high quality. There was a repair shop on Swayne Street.

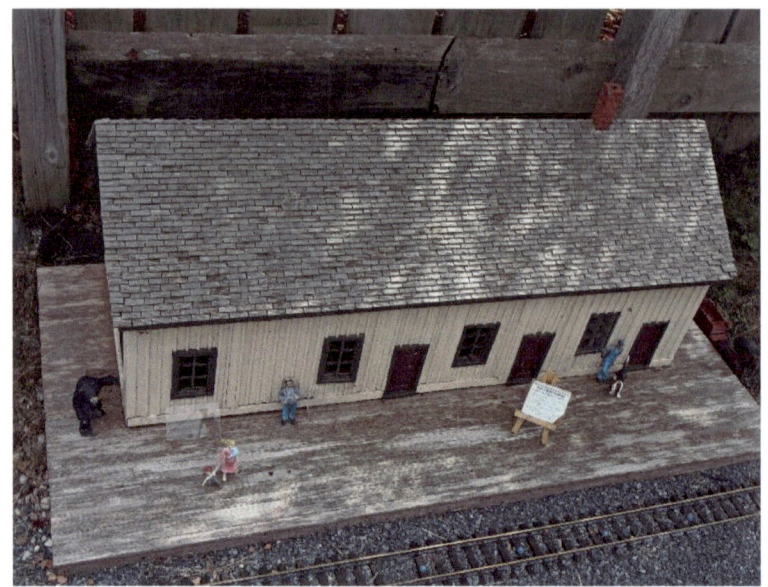

Model of Harwood Station and Wharf – Harwood was both a source and a transfer point for materials and passengers for the railway. Two local sawmills with rail connections provided lumber for shipping to Cobourg. After the demise of the bridge across Rice Lake in 1861, Harwood served as a transfer point for iron ore arriving by barge from Blairton mine via Trent River Landing, and passengers arriving by steamship from Peterborough and Keene.

136 Orr Street – Royal Canadian Legion

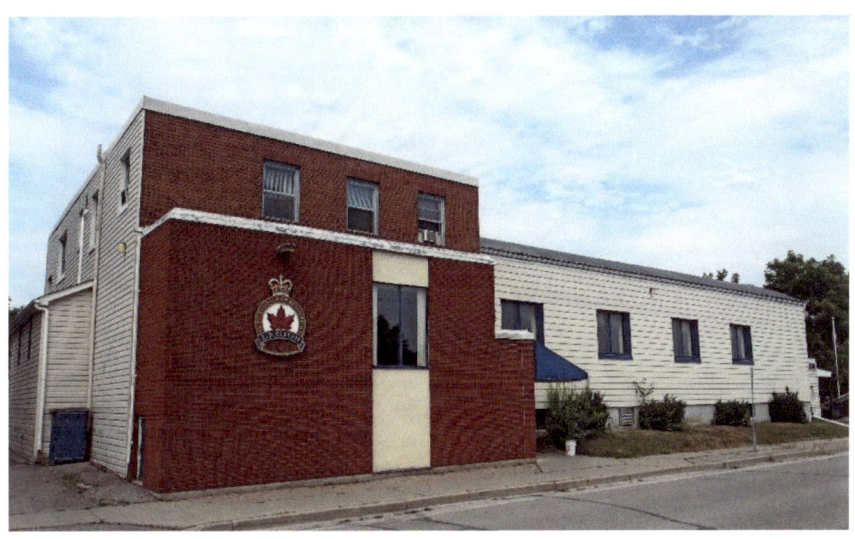

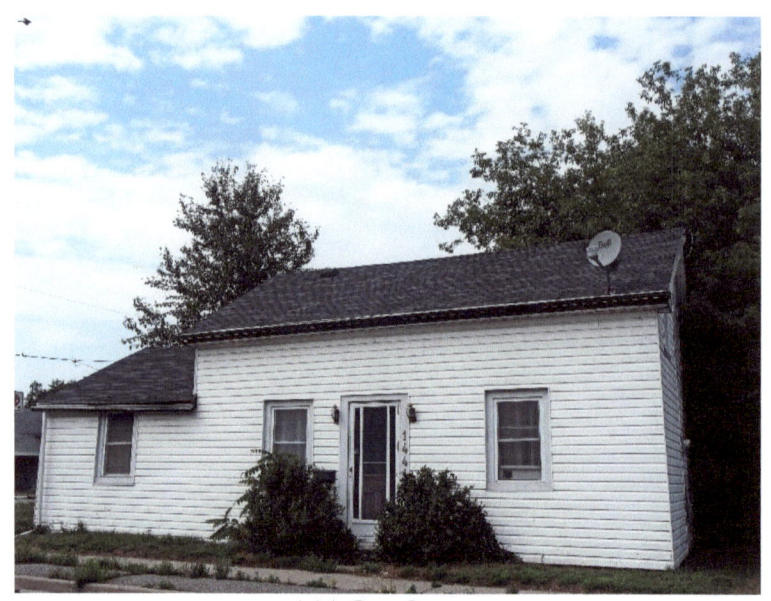

144 Orr Street

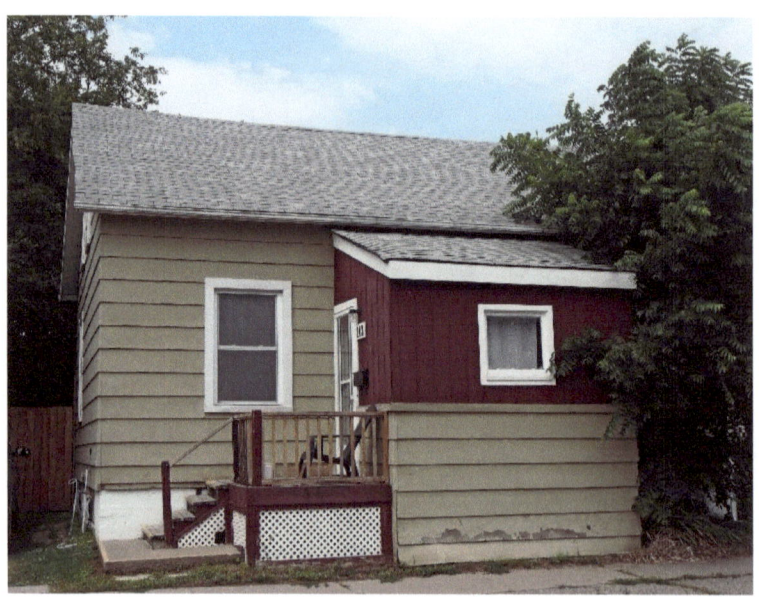

147 Orr Street

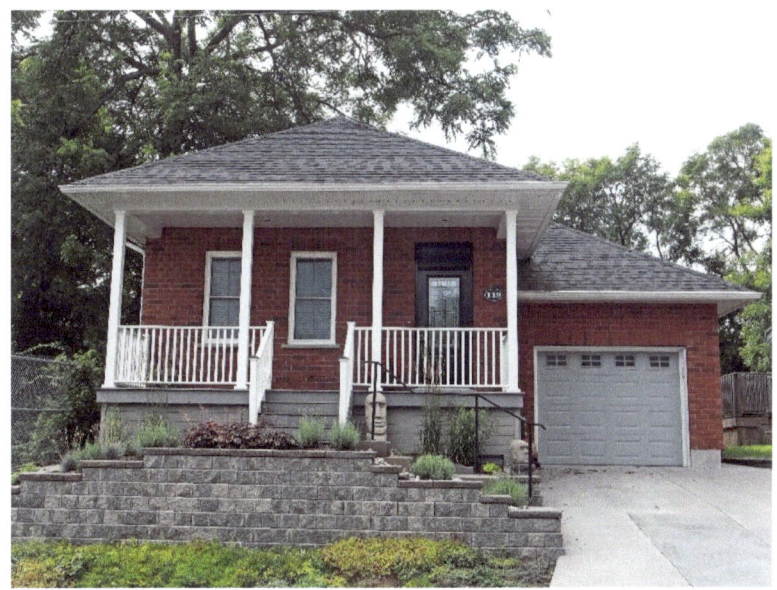

119 Durham Street

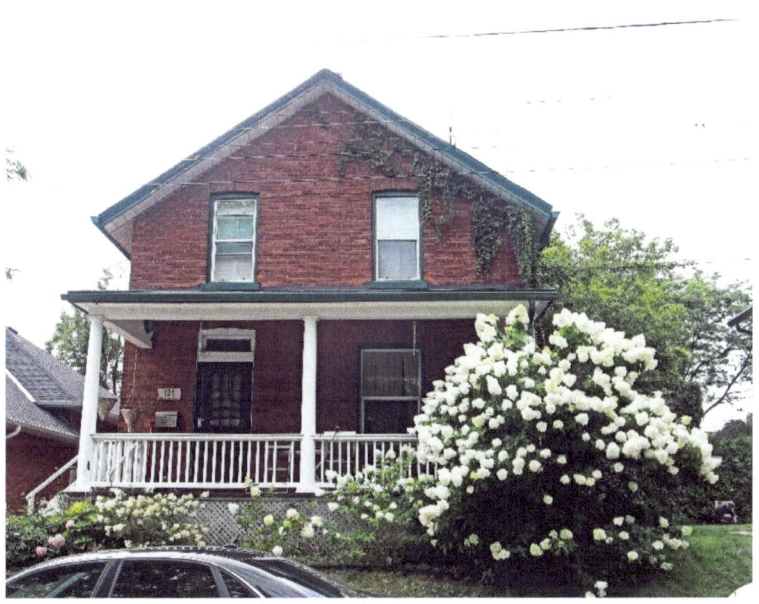

121 Durham Street

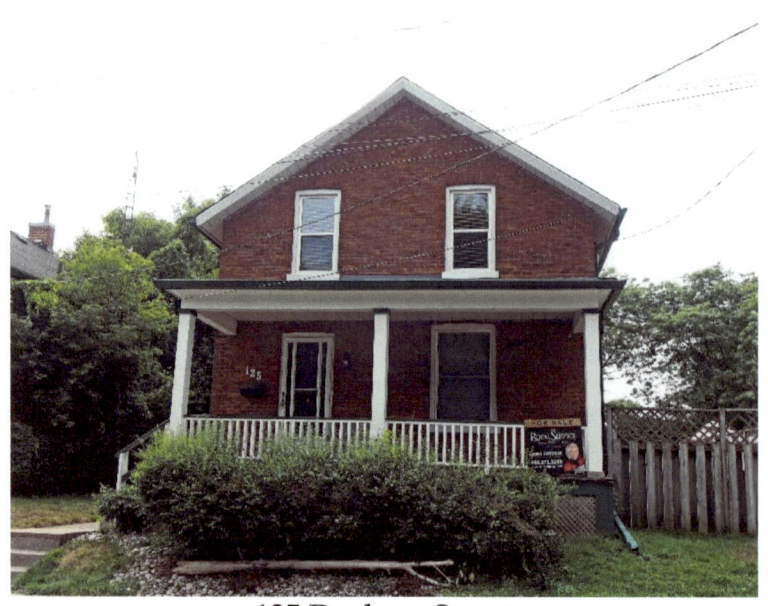

125 Durham Street

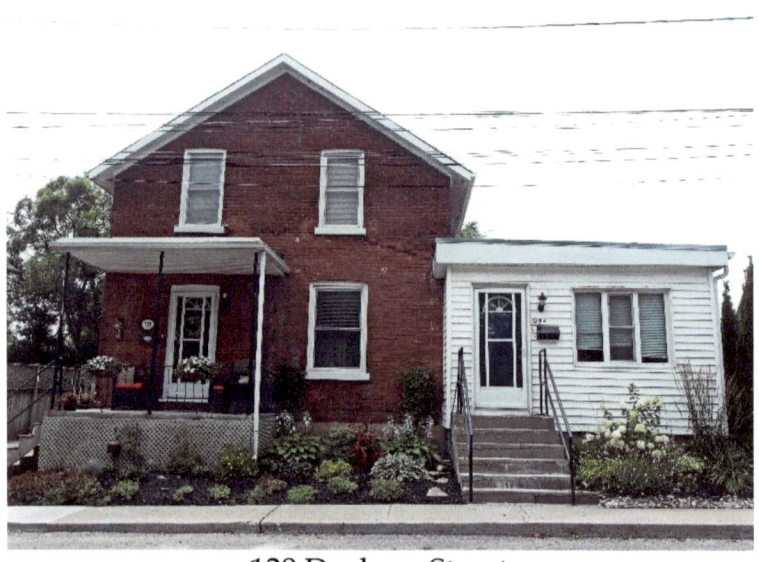

129 Durham Street

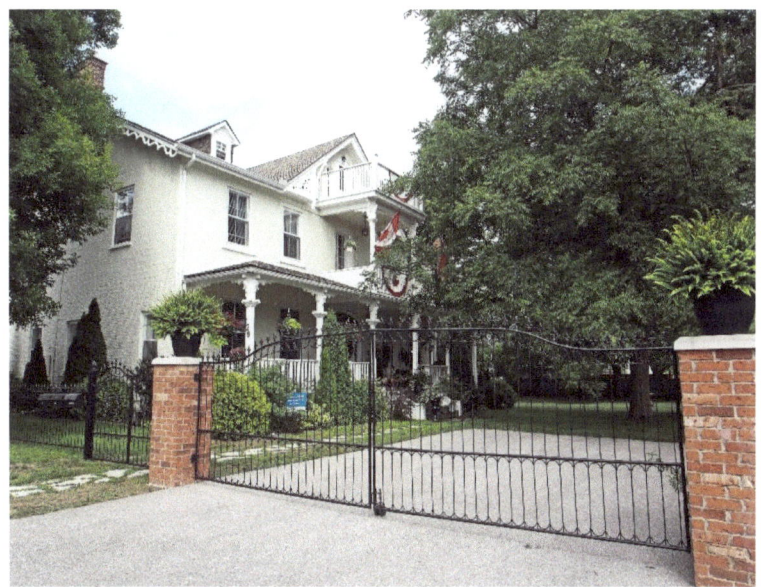

128 Durham Street – "Lakehurst", 1832 - This Georgian style house was built by James Calcutt who owned a brewery, distillery and flour milling business. This was later the home of Judge John D. Armour, a Chief Justice of Ontario and of the Supreme Court of Canada. - verge board trim on gables, dormers

155 Durham Street – verge board trim on gable

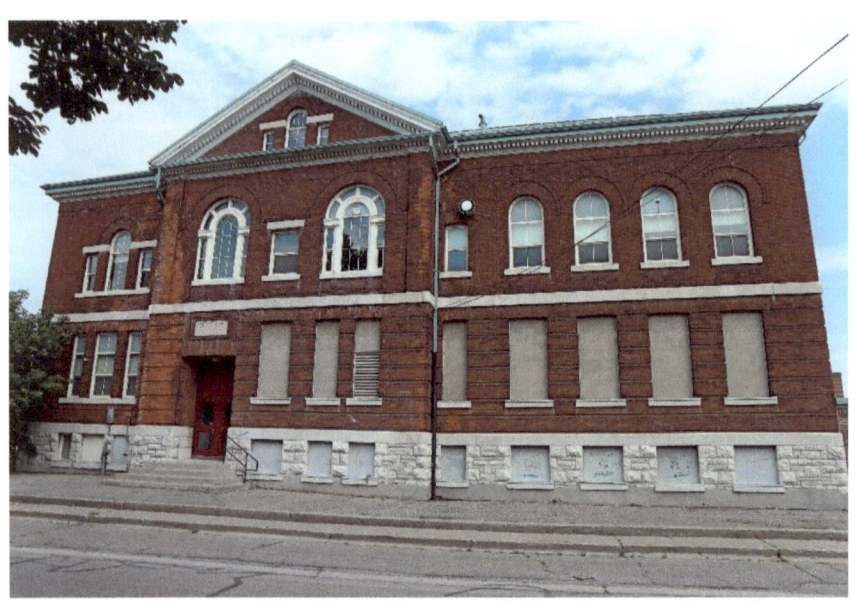

Durham Street – School

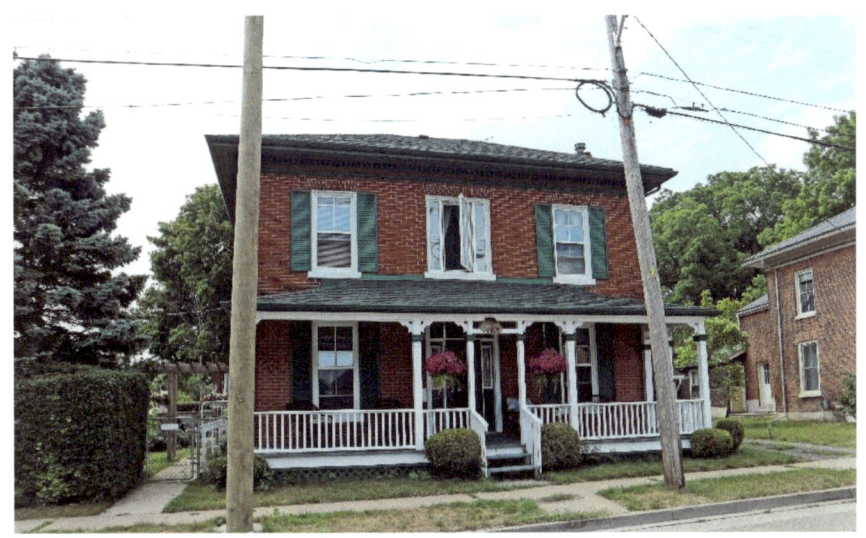

197 Durham Street – hipped roof

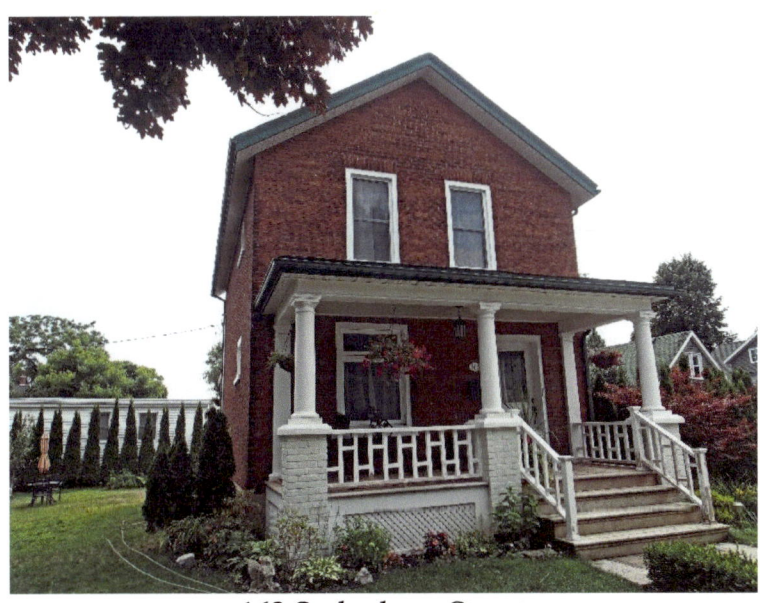

163 Sydenham Street

168 Sydenham Street

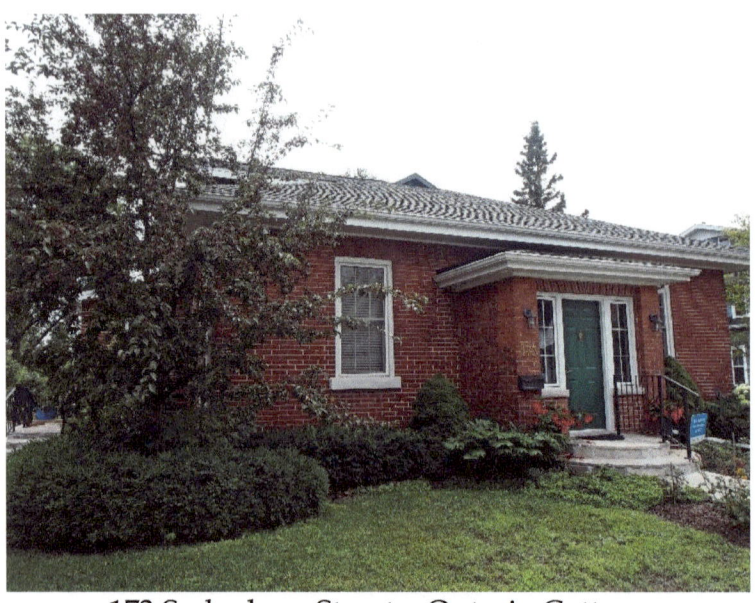
173 Sydenham Street – Ontario Cottage

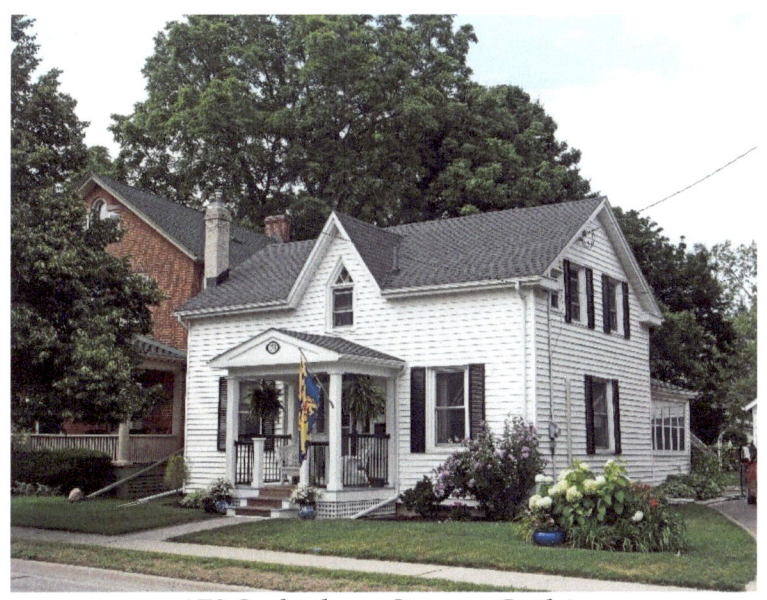

178 Sydenham Street - Gothic

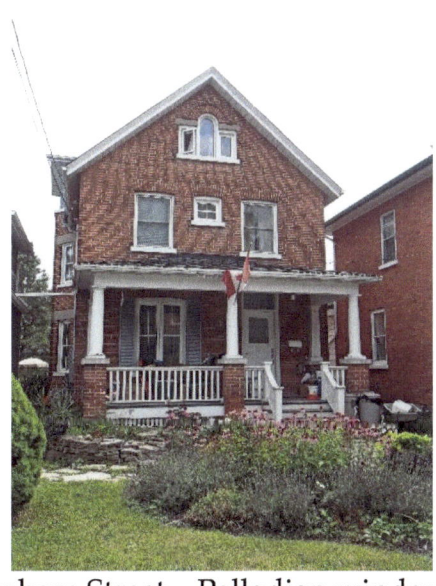

18_ Sydenham Street – Palladian window in gable

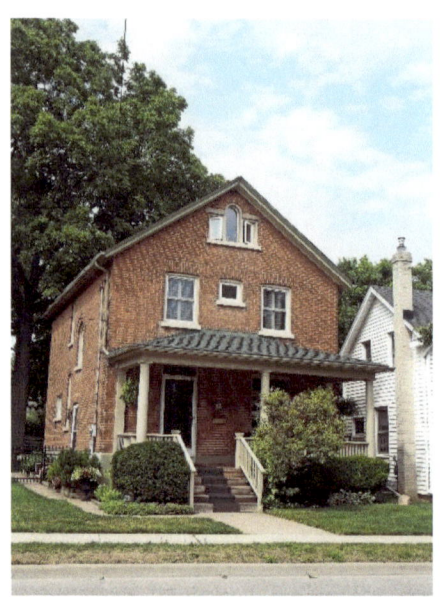

186 Sydenham Street

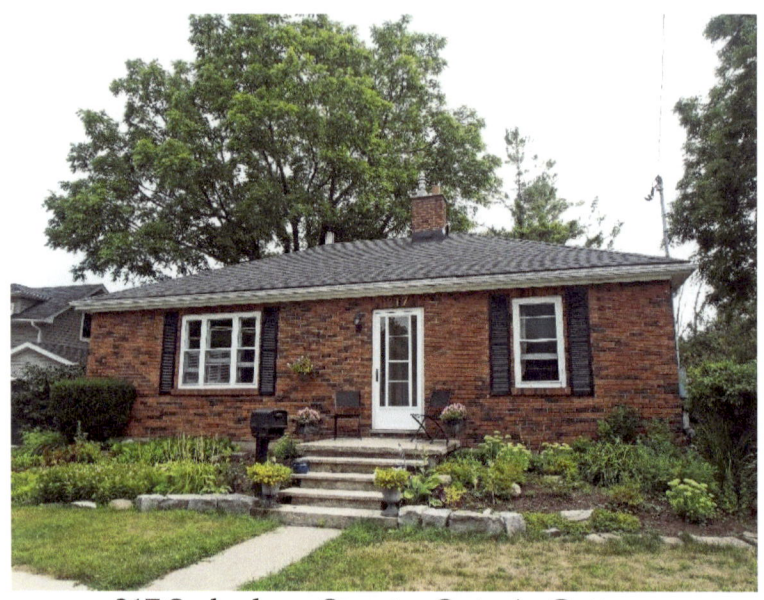

217 Sydenham Street – Ontario Cottage

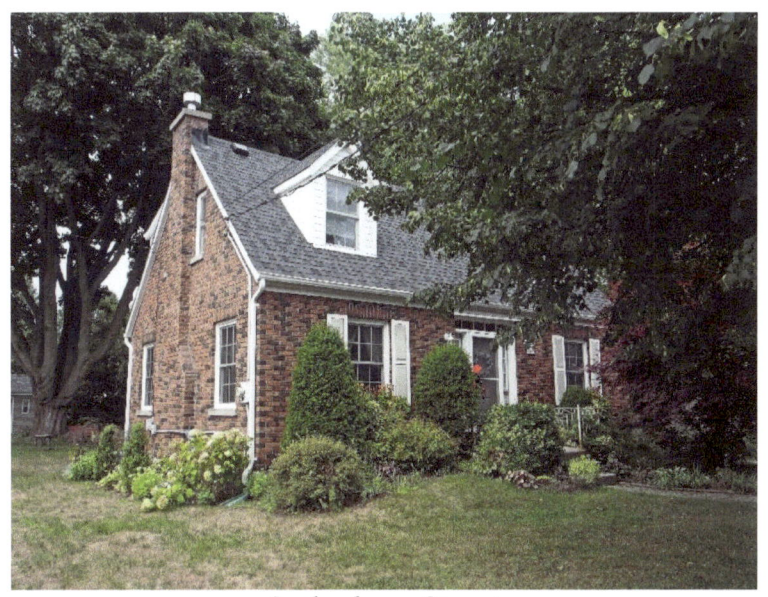

Sydenham Street

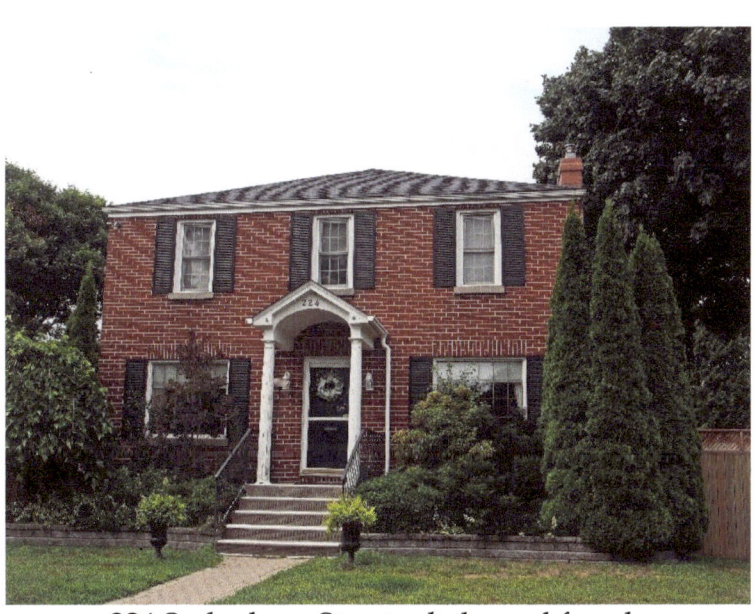

224 Sydenham Street – balanced façade

210 Bagot Street

203 Bagot Street

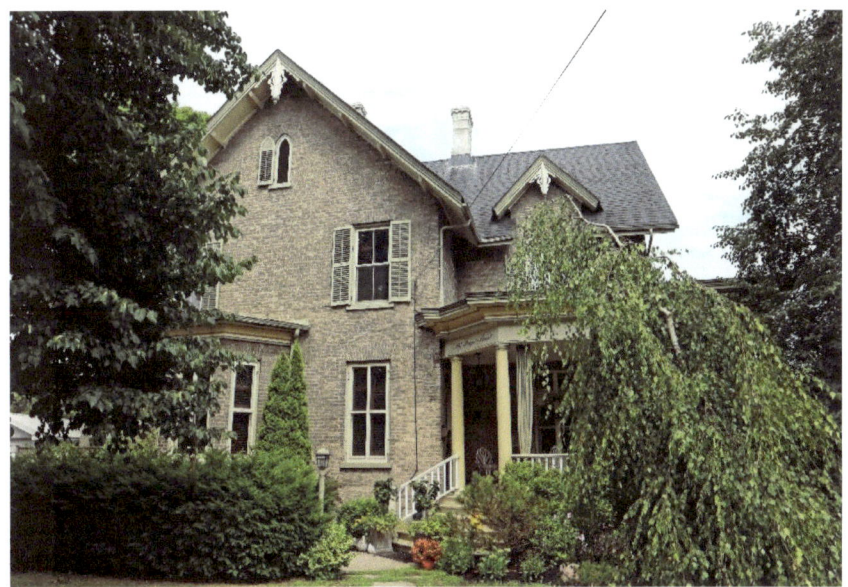

198 Bagot Street – John Thompson, a local builder and contractor built this French Villa about 1875, bay windows, narrow Gothic windows, small gable over front door

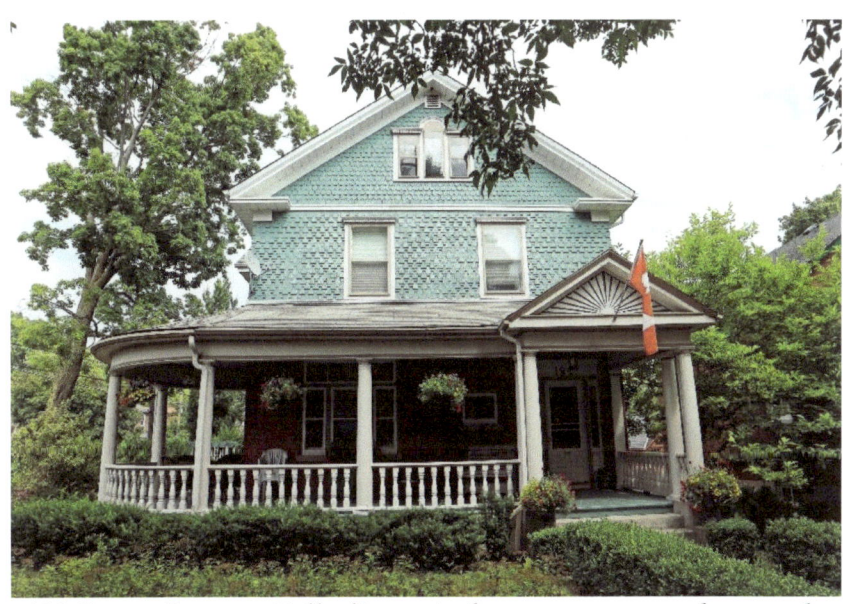

182 Bagot Street – Palladian window, wraparound veranda

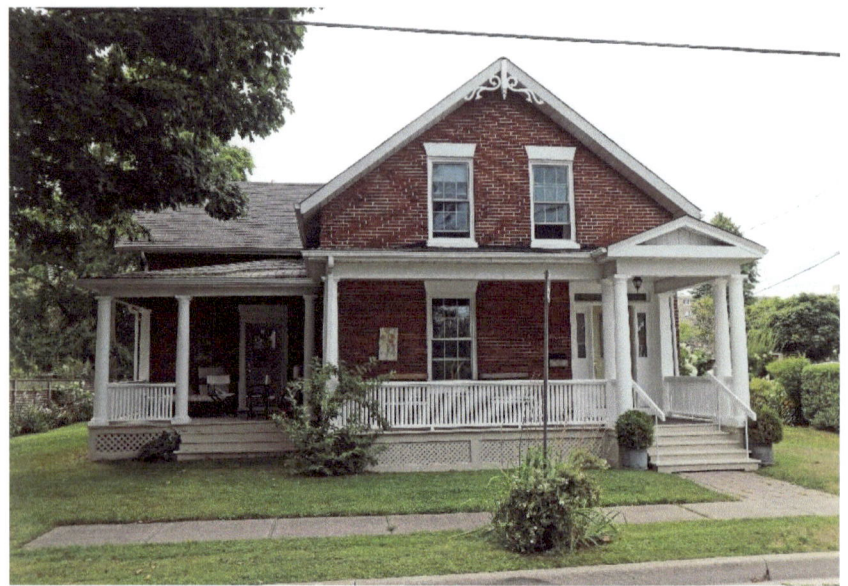

181 Bagot Street – built by Hugh Harper in the 1870s – bargeboard and finial in the gable, sidelights and transom, pediment supported by porch pillars

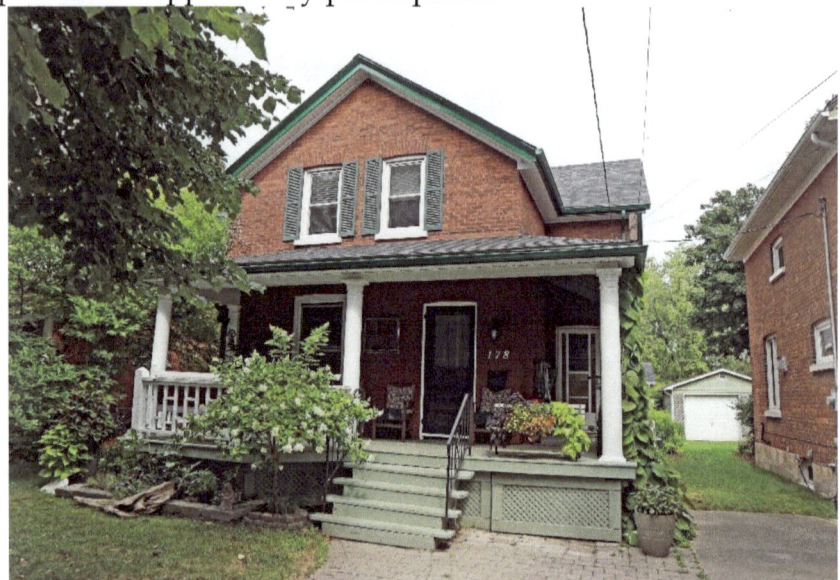

178 Bagot Street

171 Bagot Street – built by Hugh Harper in the 1870s, finial on gable

168 Bagot Street

164 Bagot Street

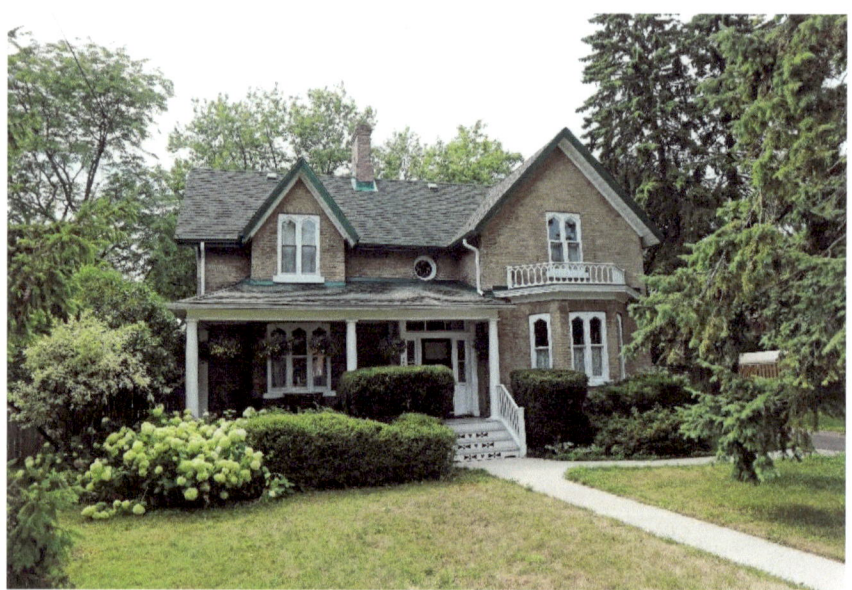

163 Bagot Street – Gothic – iron cresting above bay window

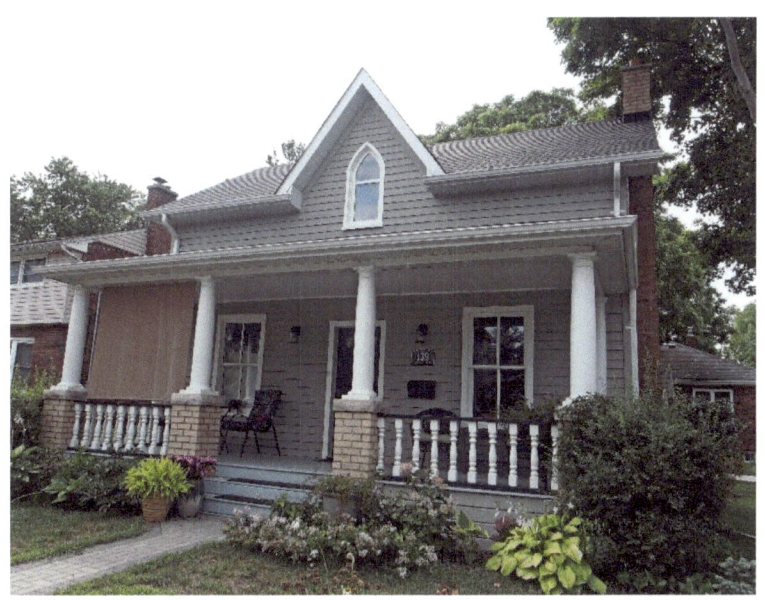

139 Bagot Street – Gothic Ontario Cottage

135 Bagot Street

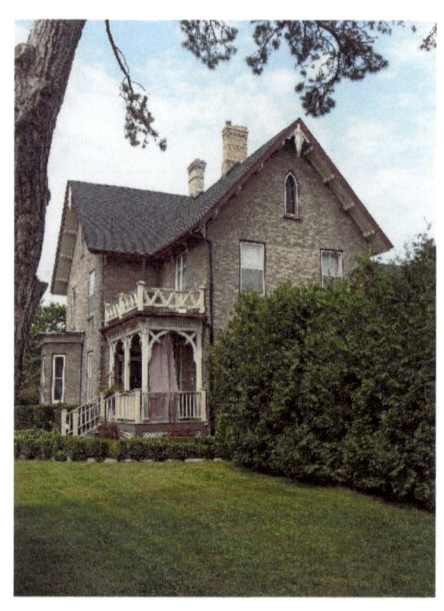

138 Bagot Street

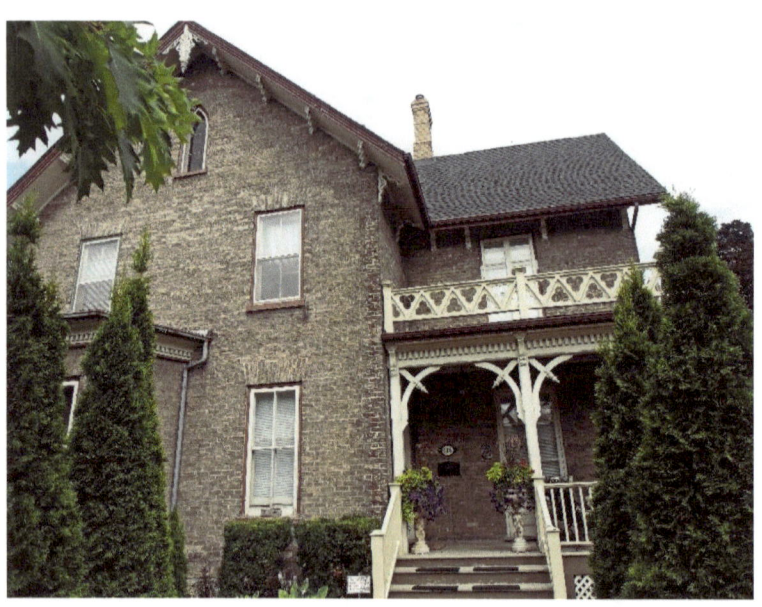

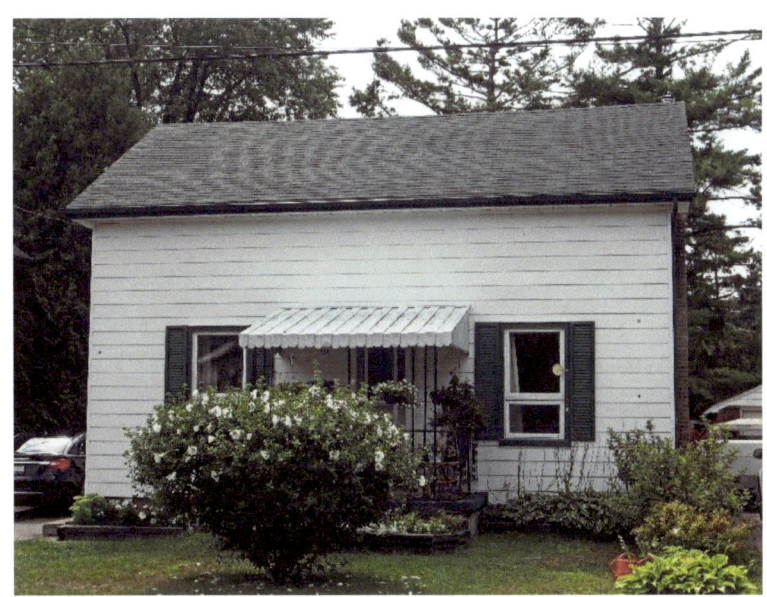

131 Bagot Street

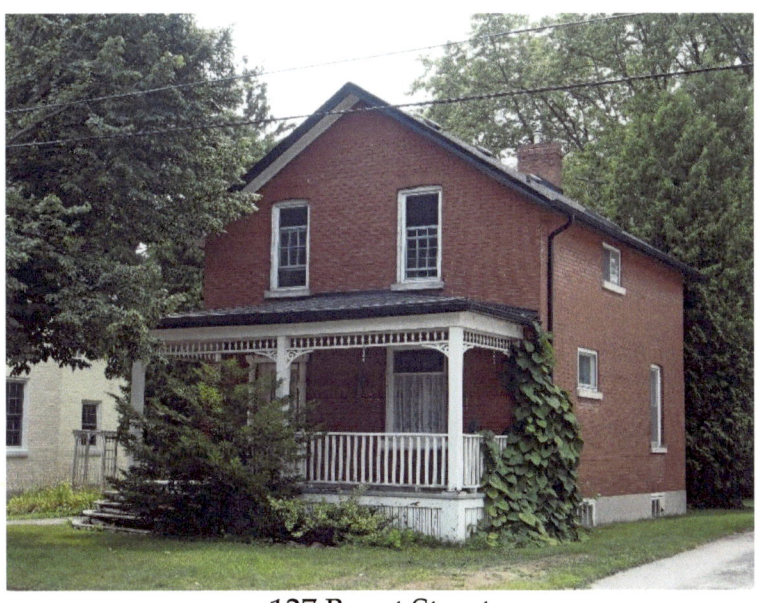

127 Bagot Street

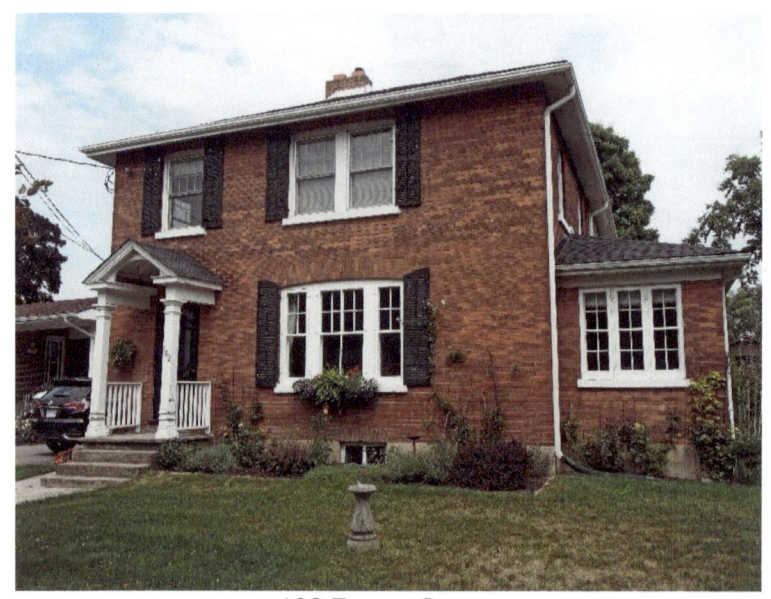

122 Bagot Street

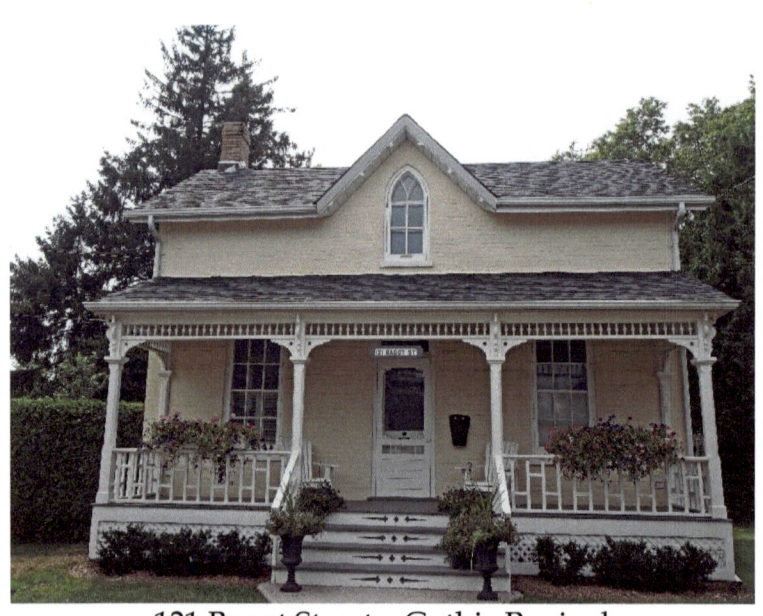

121 Bagot Street – Gothic Revival

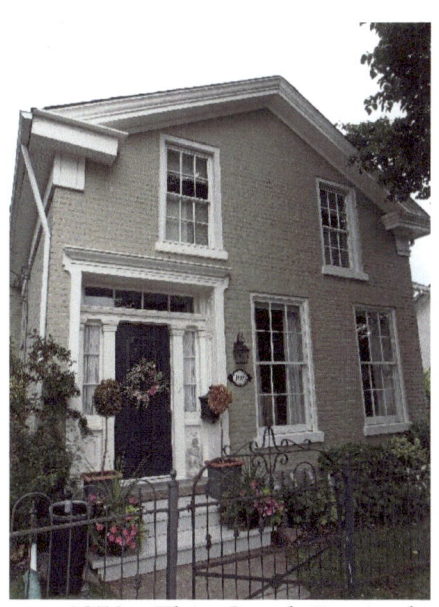

106 Bagot Street - c. 1850 - This Greek Revival cottage was built by William H. Floyd. Constructed of brick, it has simple clean lines, with good returning eaves and a plain cornice. The off-center doorway is a unique example of the extent to which the Greek Revival could go in elaborate detail.

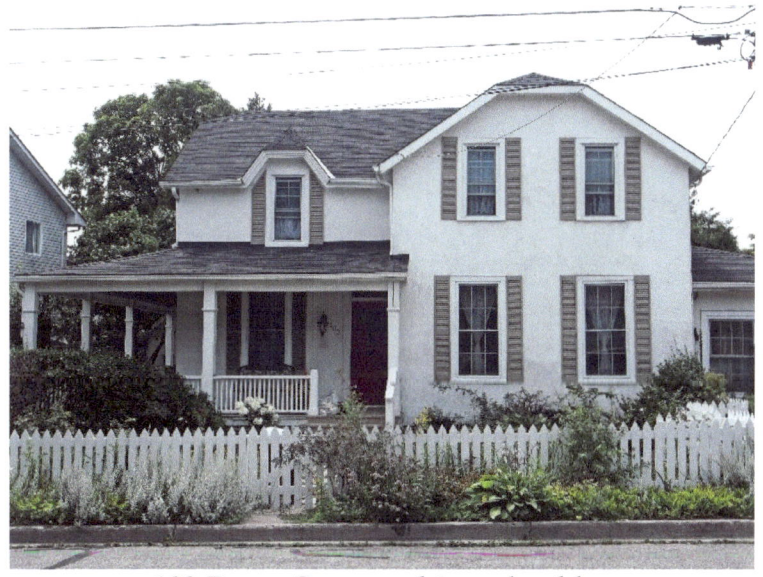

103 Bagot Street – chipped gables

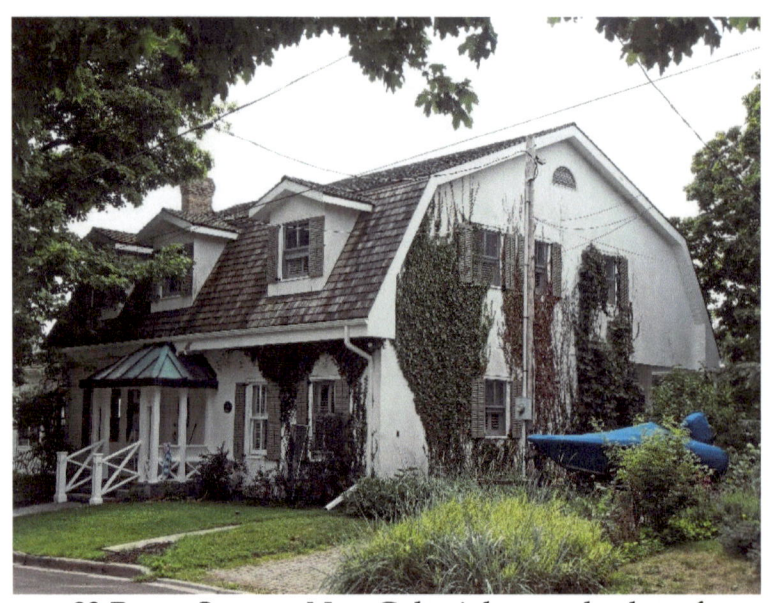

93 Bagot Street – Neo-Colonial – gambrel roof

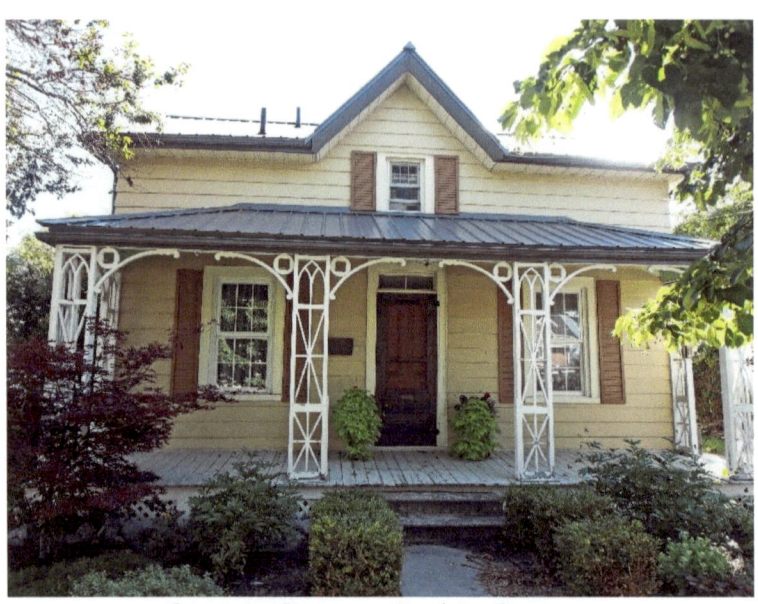

Ontario Street – Gothic Cottage

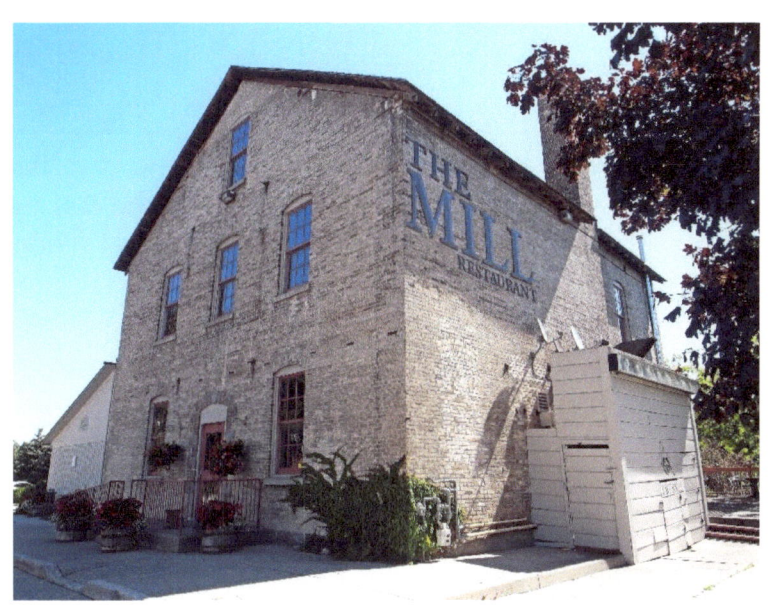

990 Ontario Street – The Mill Restaurant

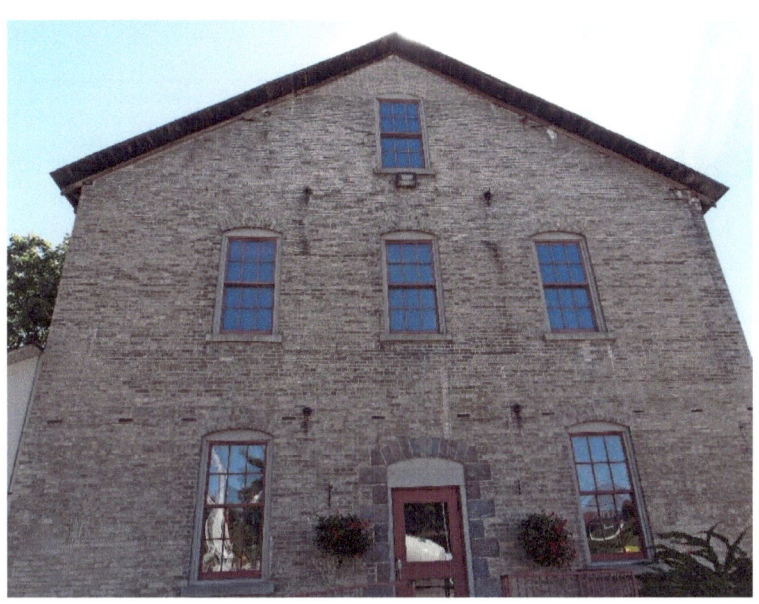

In 1836, Asa Burnham, a Cobourg pioneer, sold his property at Elgin and Ontario Streets to Ebenezer Perry, a United Empire Loyalist, a veteran of the War of 1812. Perry's Mill was constructed of stone; it was destroyed in a fire and rebuilt of brick in the 1850s with some stone work around the entrance. In 1870, Mr. Poe added a plaster mill which required schooner loads of stone to be brought in for grinding. He also continued to run the flouring mill. By 1889 the Pratt family owned the mill and continued there until 1986. Alexander Pratt owned a flour and seed store in Cobourg and leased the flour mills in Baltimore. His interests in the mill began in May 1883 when the Cobourg Flour Milling Company was converting the old grindstone mill into the more efficient device known as the roller mill.

702 Ontario Street

664 Ontario Street

Ontario Street

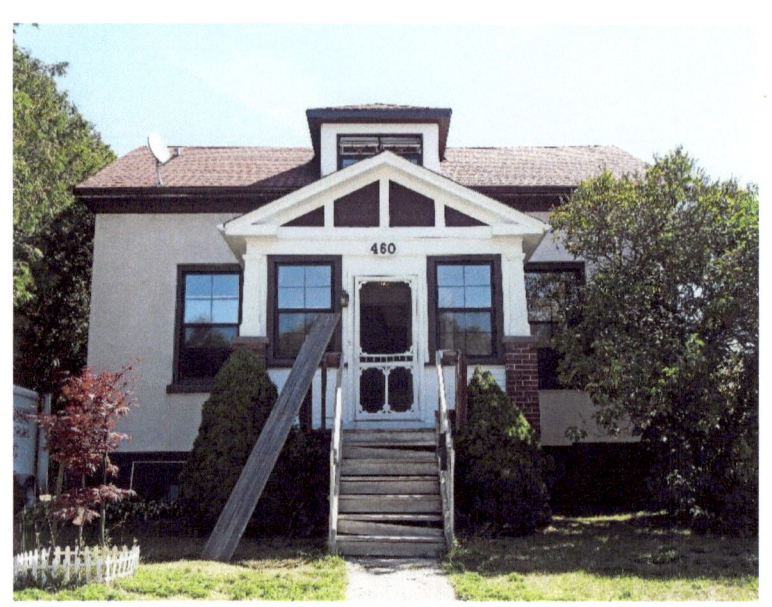

460 Ontario Street

410 Ontario Street

381 Ontario Street

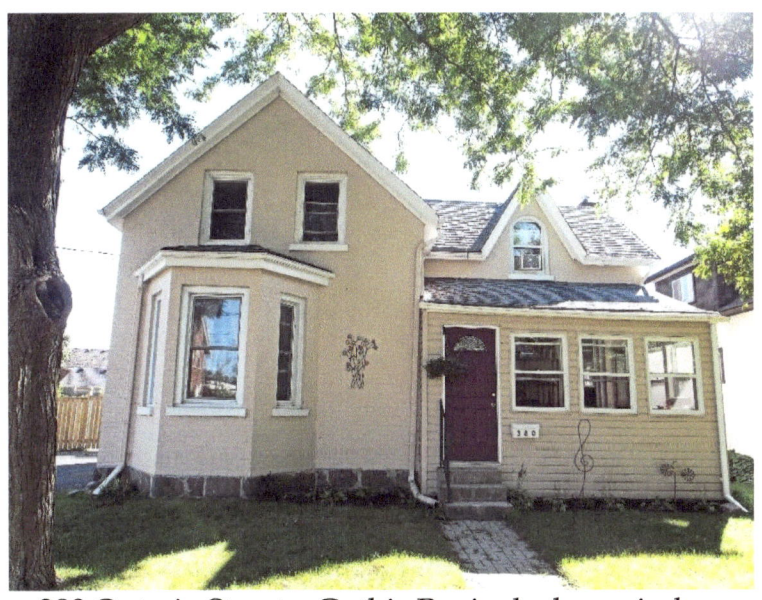

380 Ontario Street – Gothic Revival – bay window

376 Ontario Street

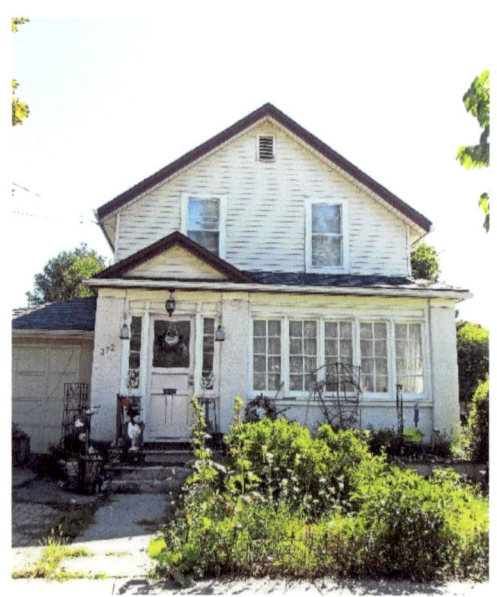

372 Ontario Street

363 Ontario Street

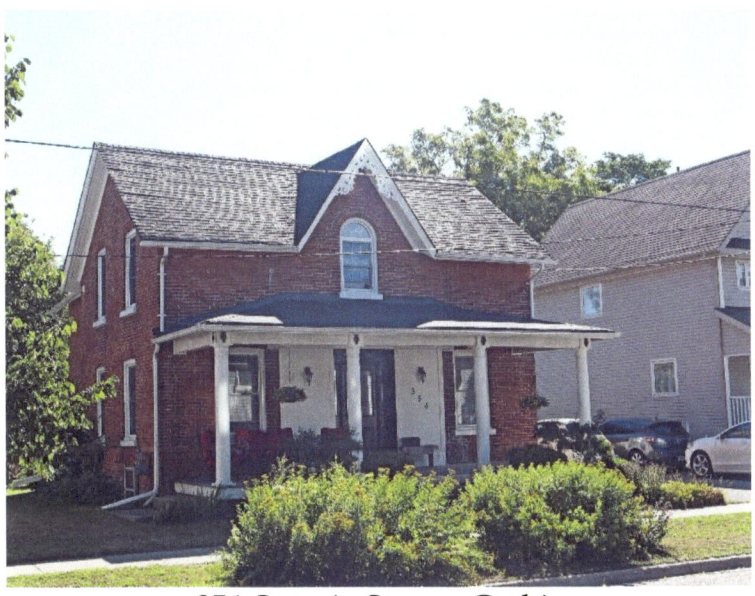

354 Ontario Street - Gothic

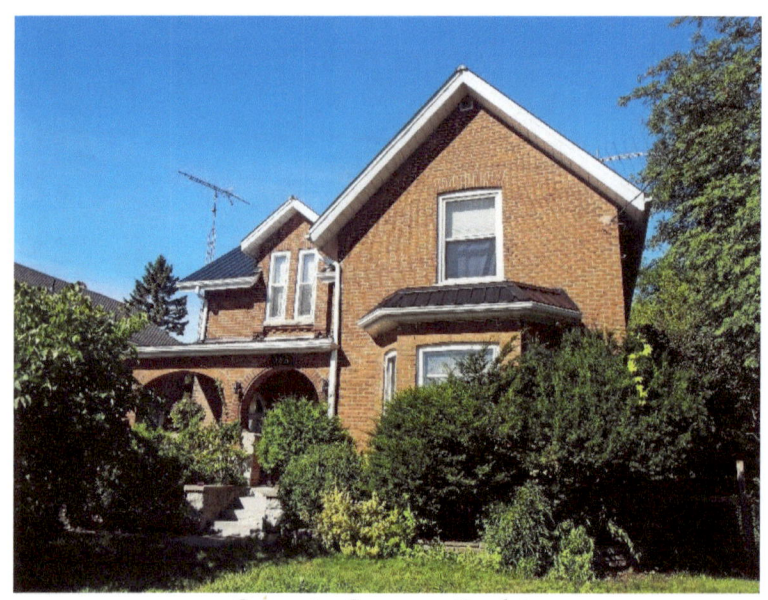

Ontario Street - Gothic

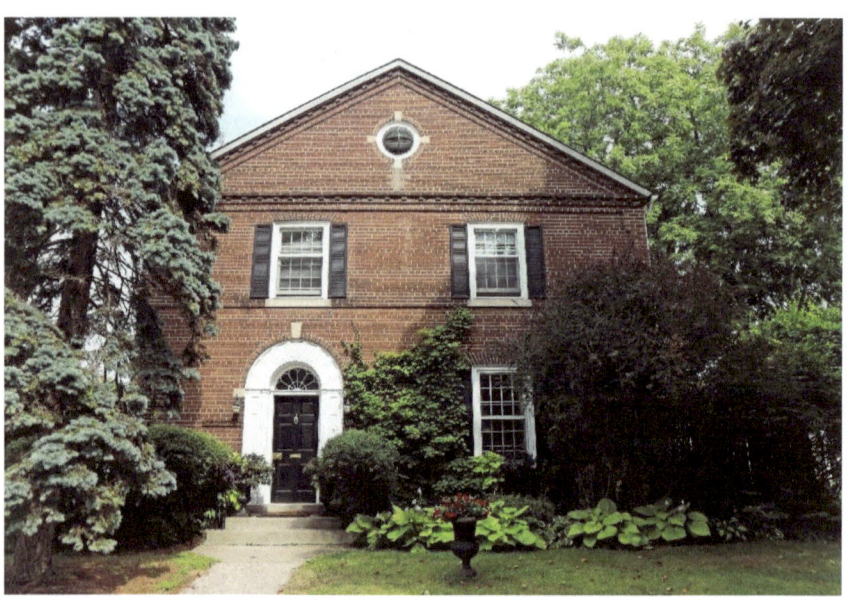

184 Ontario Street – The Field House

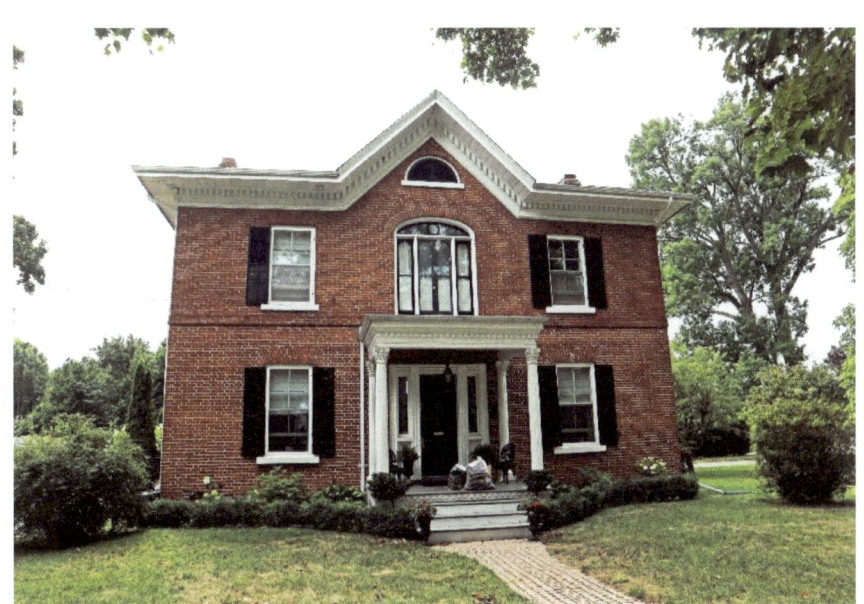

181 Ontario Street – 1844 – second storey added later – truncated hip roof, front French door with sidelights

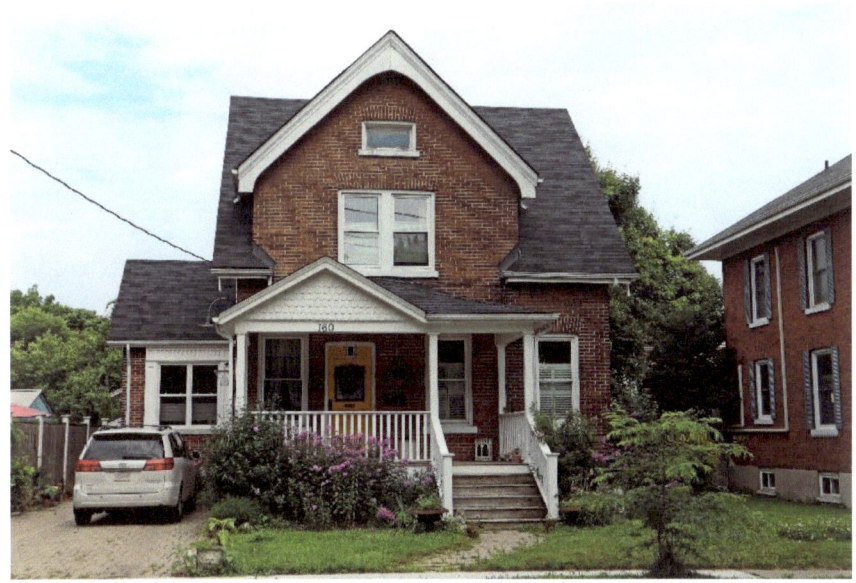

160 Ontario Street

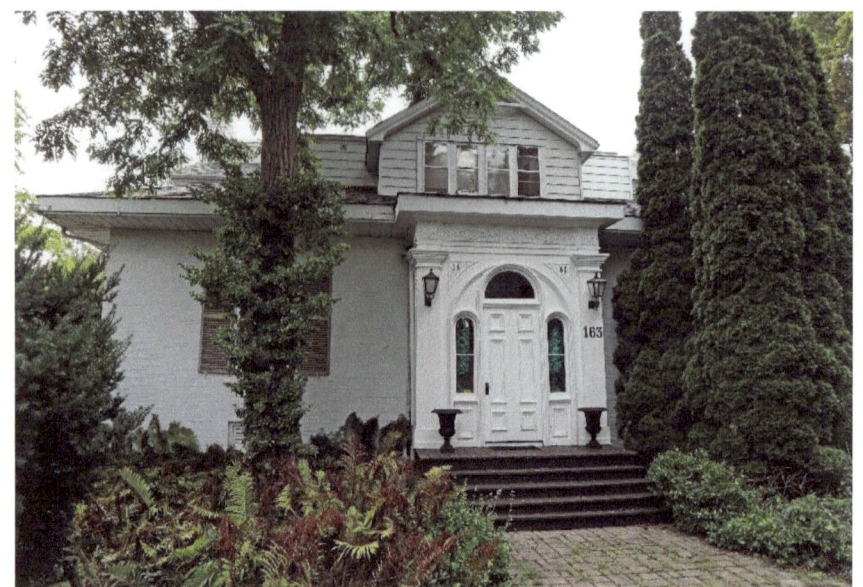

163 Ontario Street – 1843 – built by one of the four Burnet brothers - front porch added in 1862 – the ornamented entablature of the porch is supported by two large square pillars and an elaborate frieze with a central crest at the top.

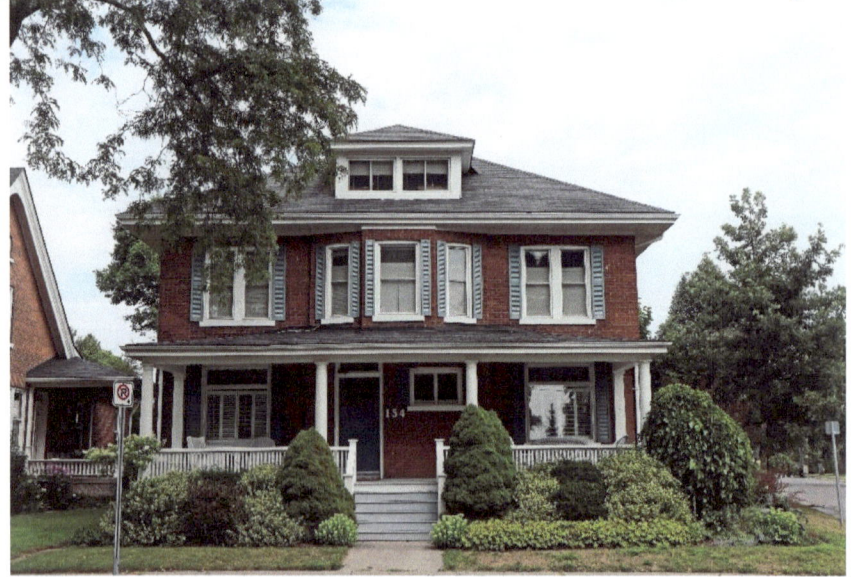

154 Ontario Street

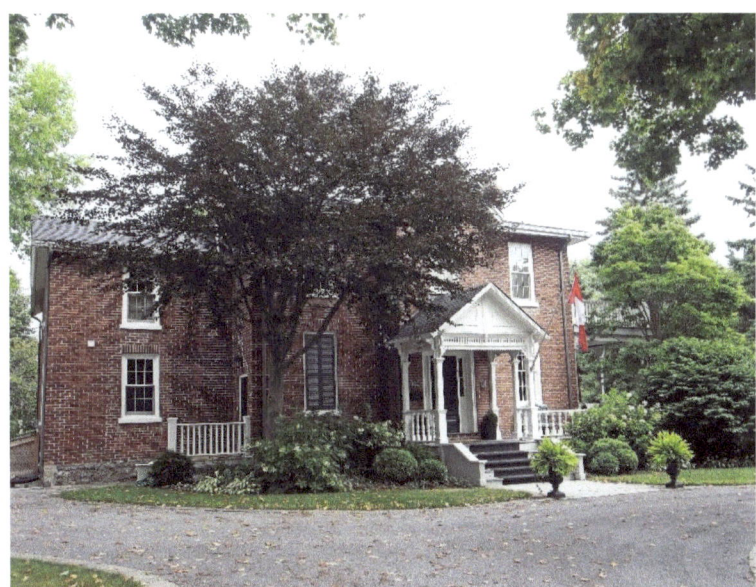

132 Ontario Street – 1862 - The ornate porch and its handsome window are the main features of this interesting house built in 1862 by George Goodeve.

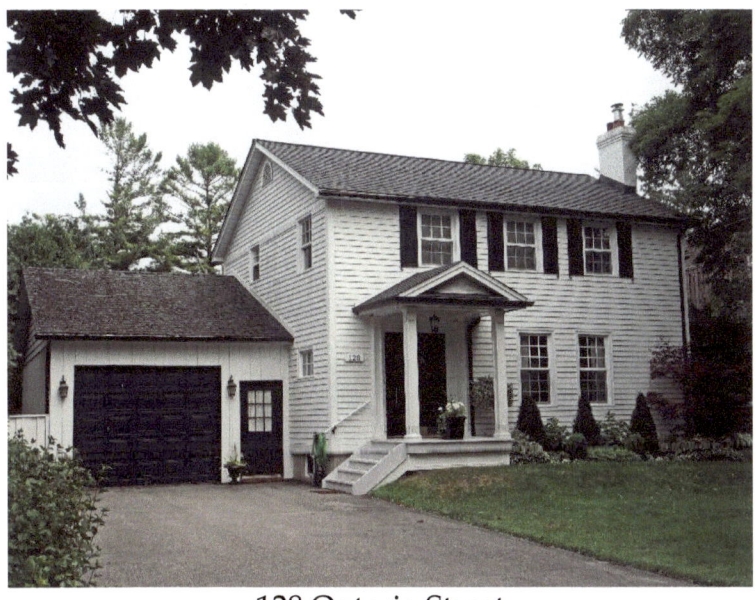

128 Ontario Street

120 Ontario Street

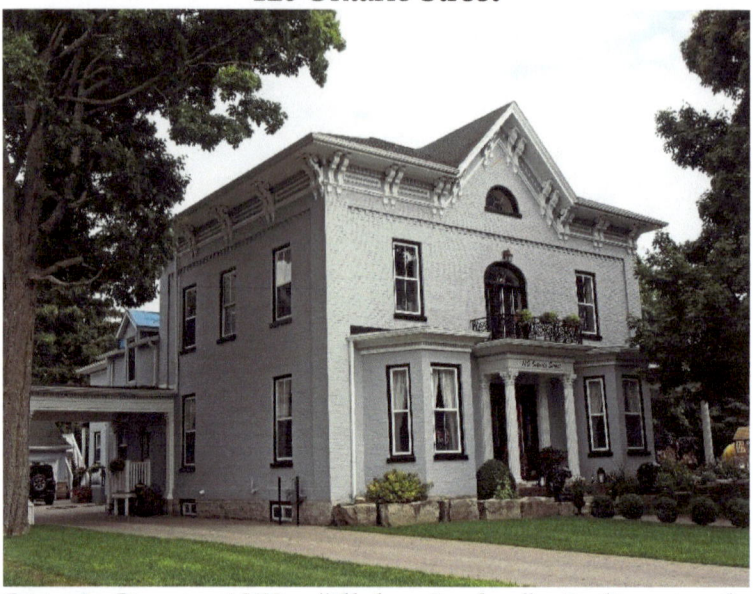

110 Ontario Street – 1878 – "Illahee Lodge" – Italianate – built by John Jeffrey, hardware merchant – bay windows, front porch crowned with intricate wrought iron railing

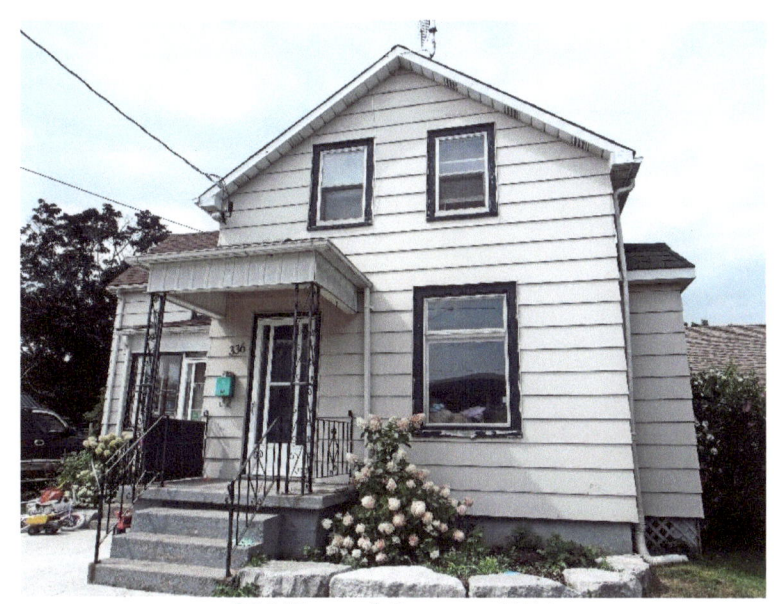

336 Tweed Street - 1856

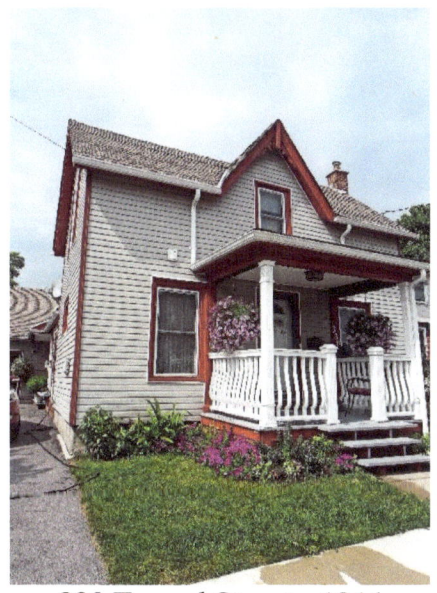

330 Tweed Street - 1846

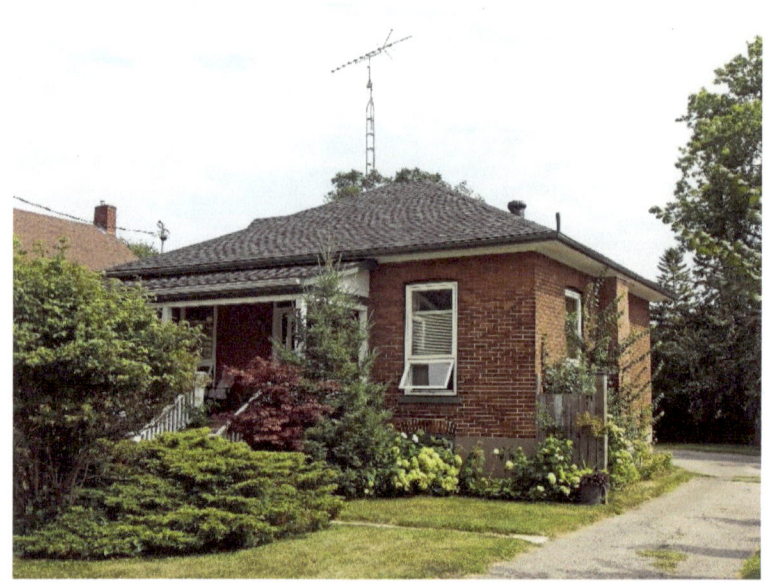

317 Tweed Street - 1880

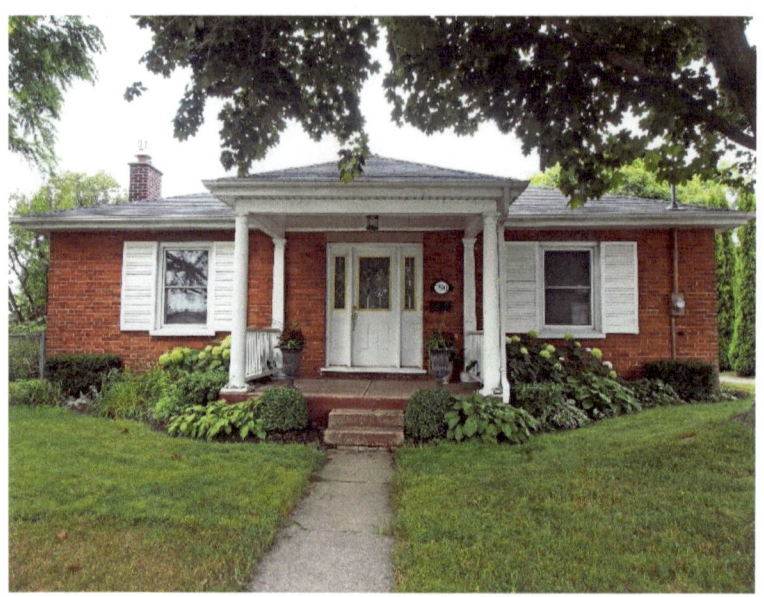

290 Tweed Street – 1850s

205 Tweed Street

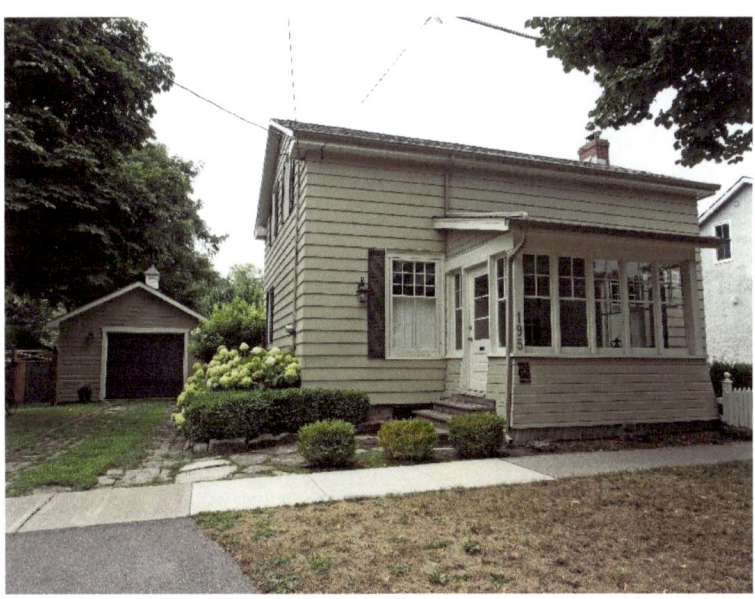

195 Tweed Street

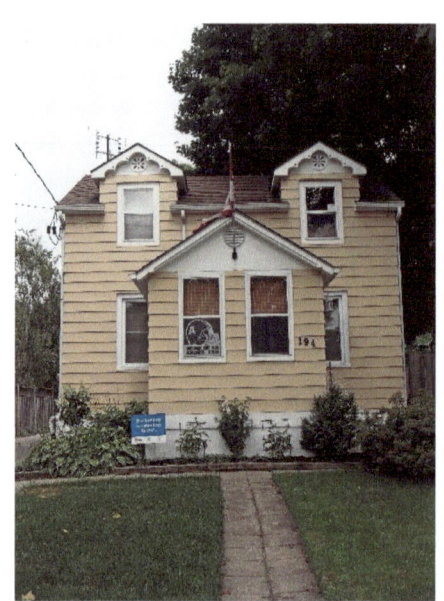

194 Tweed Street

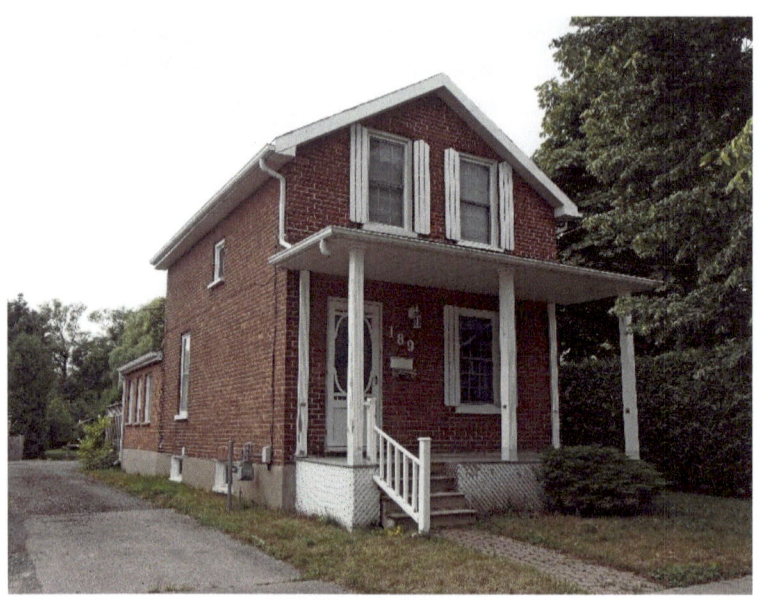

189 Tweed Street

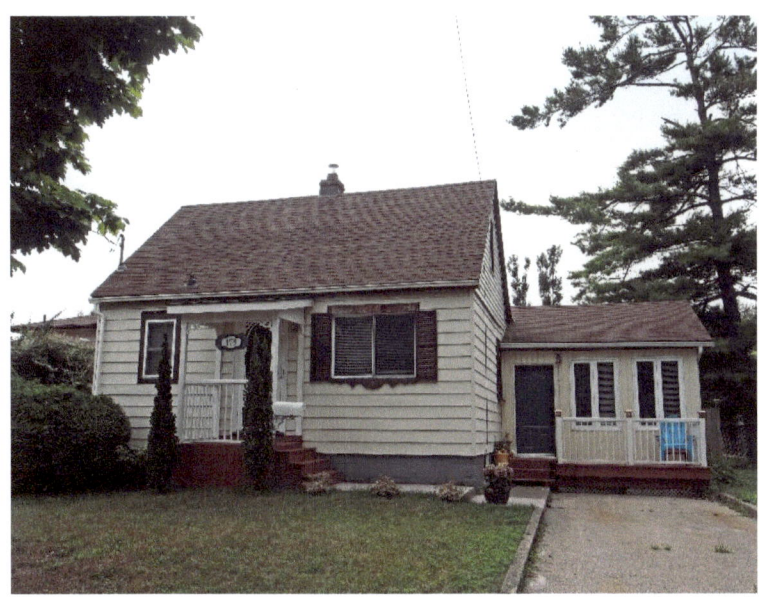

179 Tweed Street

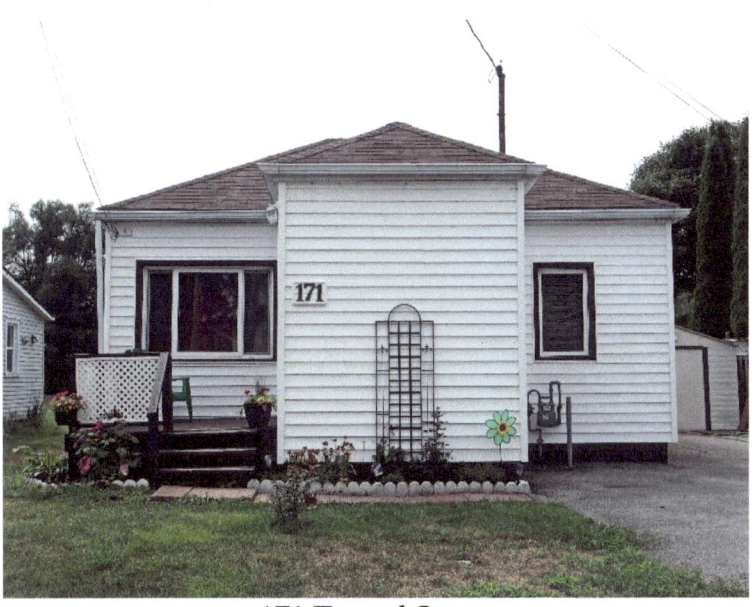

171 Tweed Street

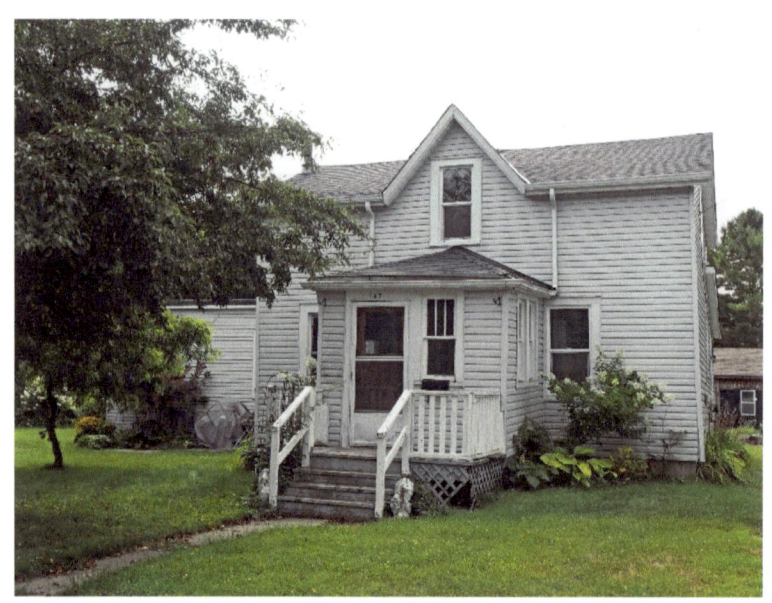

167 Tweed Street

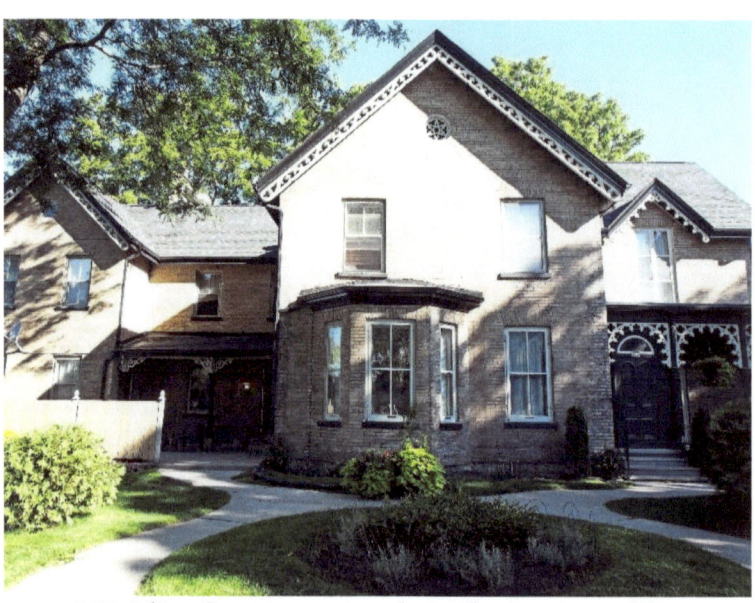

465 Alice Street – verge board trim on gables

Tremaine Street

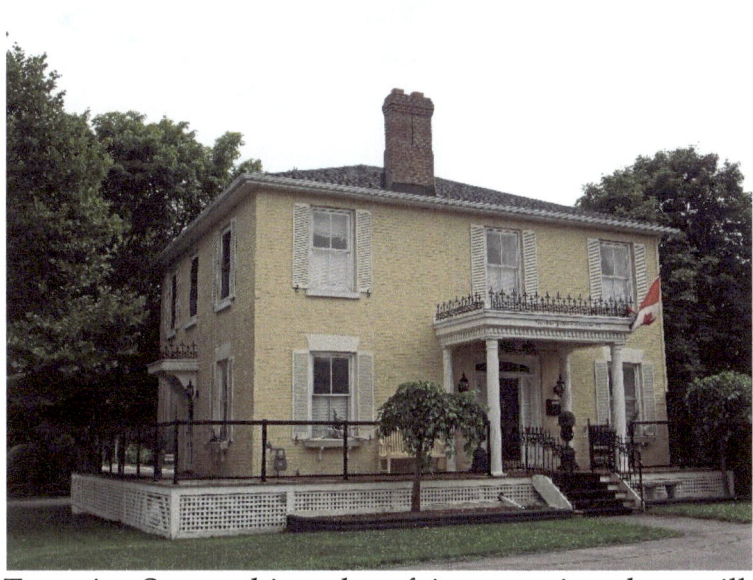

193 Tremaine Street – hipped roof, iron cresting above pillared porch

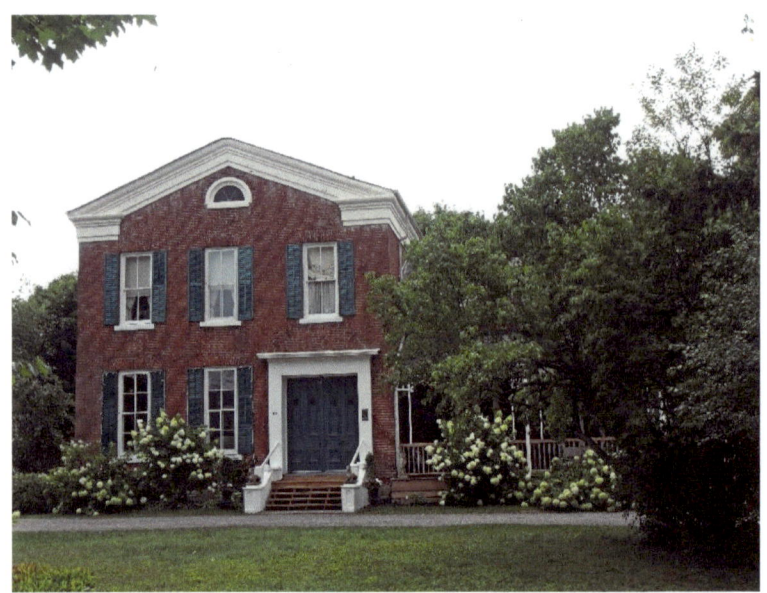

173 Tremaine Street - "Mount Fortune" 1844 - This Greek Revival home at one time served as an officers' mess for the Cobourg Cavalry Regiment. The porch treillage and molded brick cornice are note-worthy. It was owned in the 1860s by James Fortune, one-time sheriff of the District.

147 Tremaine Street – prior to 1858

134 Tremaine Street – 1854 – two storey

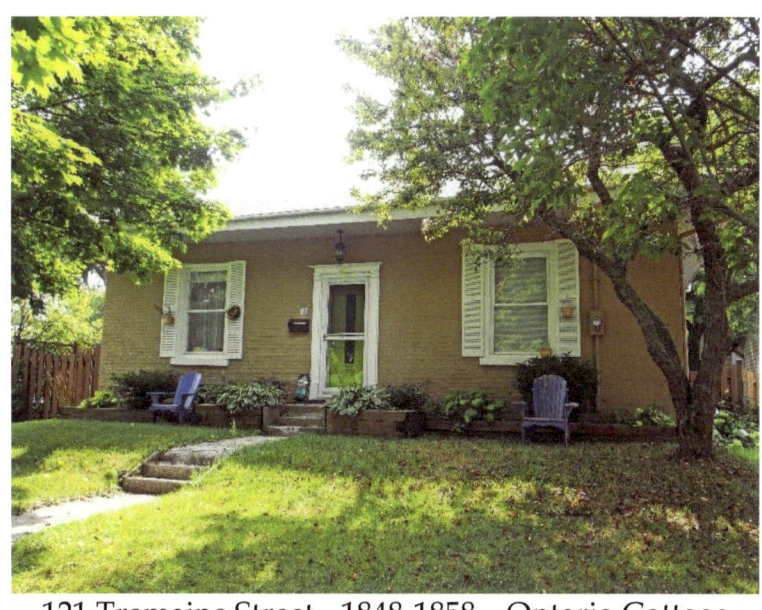

121 Tremaine Street - 1848-1858 – Ontario Cottage

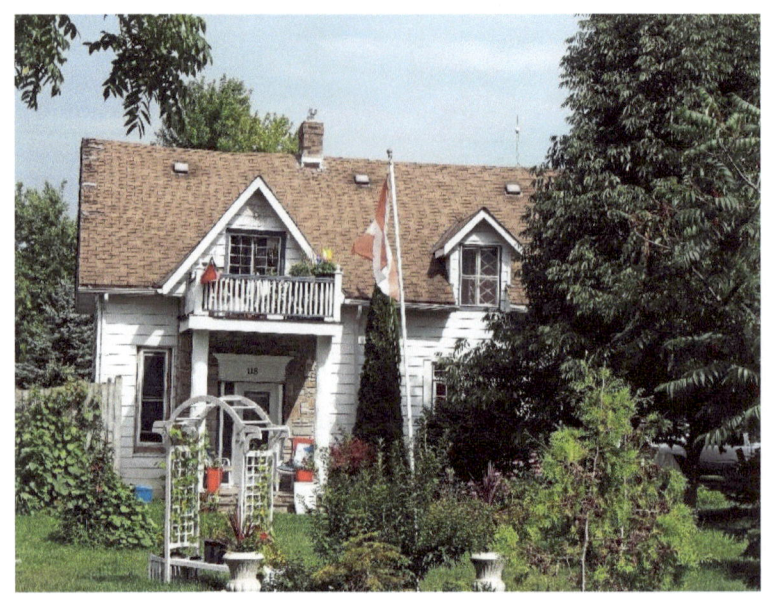
118 Tremaine Street – 1847 - Gothic Style/Greek Revival Style

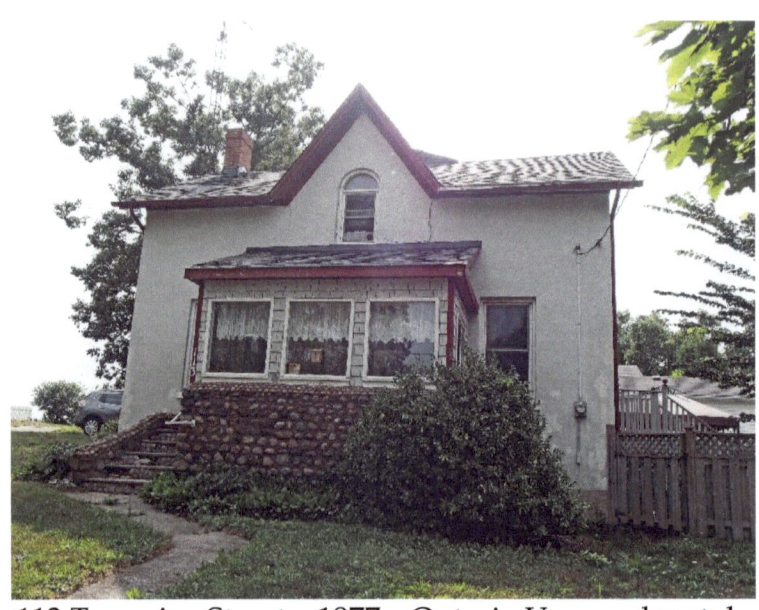
113 Tremaine Street – 1877 – Ontario Vernacular style

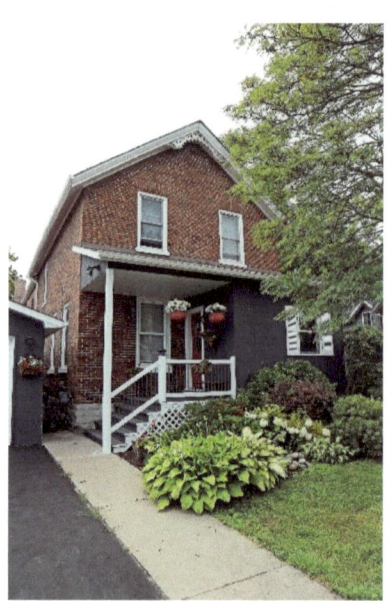
Stuart Street

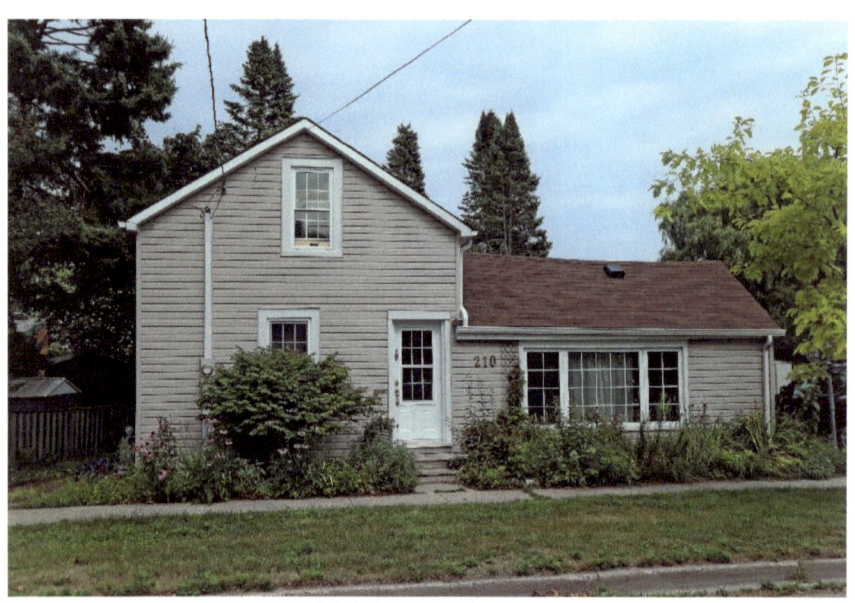
210 Stuart Street

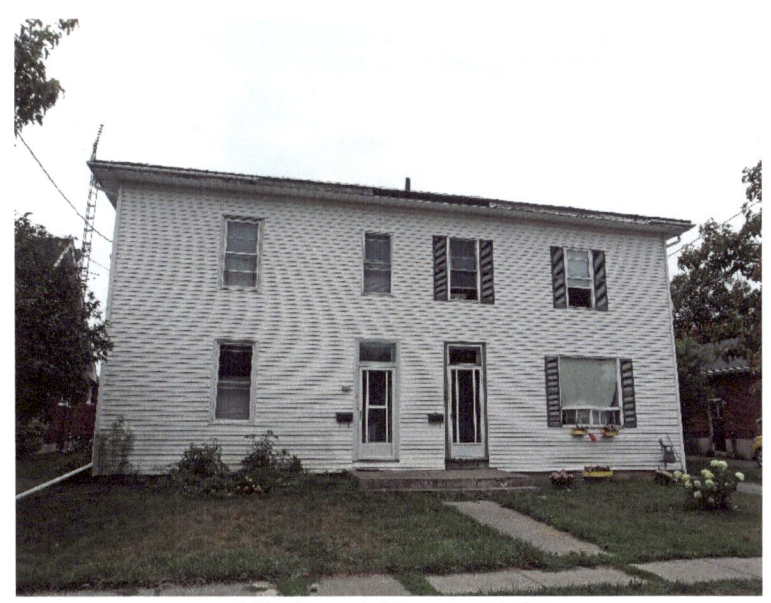

175 Stuart Street - 1885

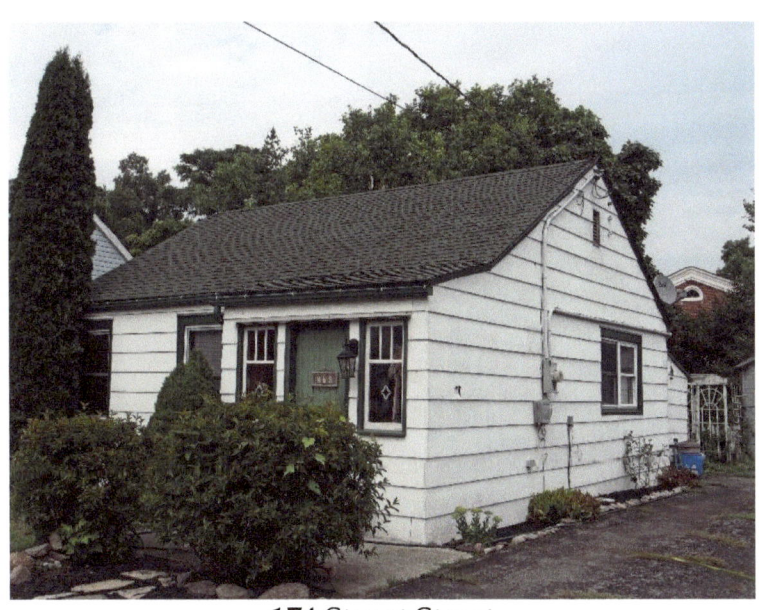

174 Stuart Street

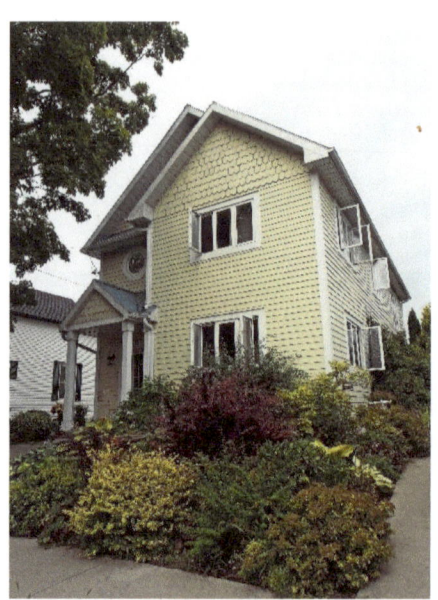

154 Stuart Street

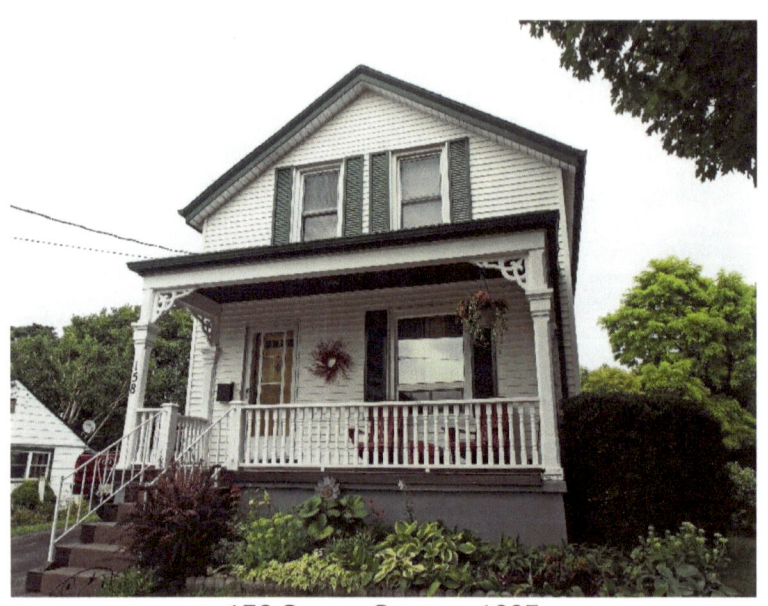

158 Stuart Street - 1885

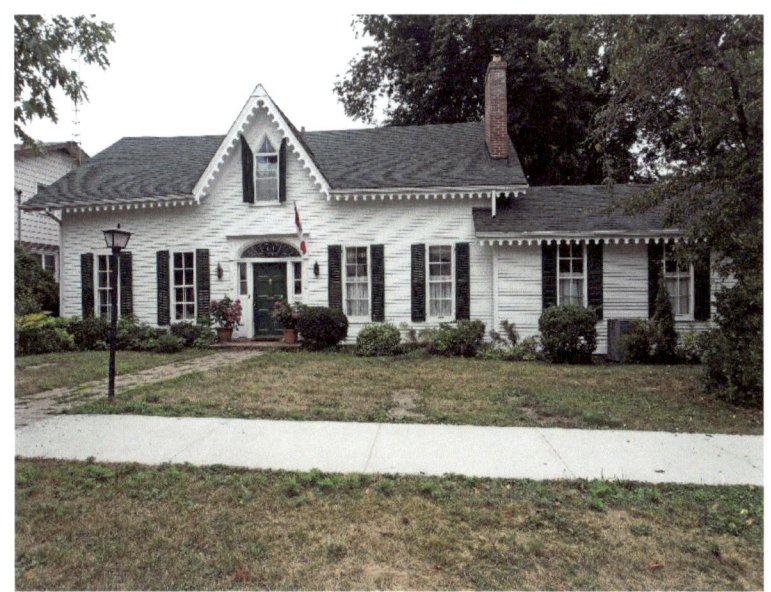

Queen Street

169 Queen Street - Tudor

177 Queen Street

195 Queen Street – c. 1855 – 1½-storey Regency style

139 Queen Street – 1873 - Built by Major William Taylor. It later belonged to Lydia Cornell, whose niece Katharine Cornell, a famous Broadway actress, was married here in 1921.

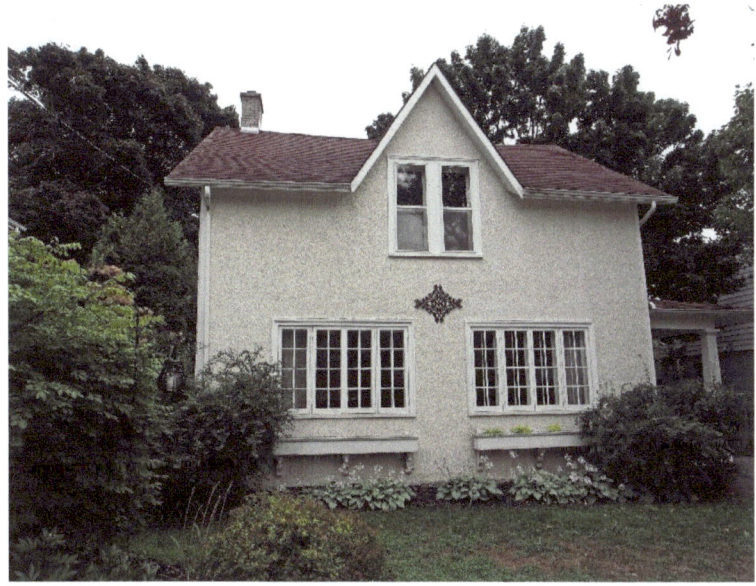

Queen Street

Queen Street

Queen Street

217 Green Street – 1844-1848

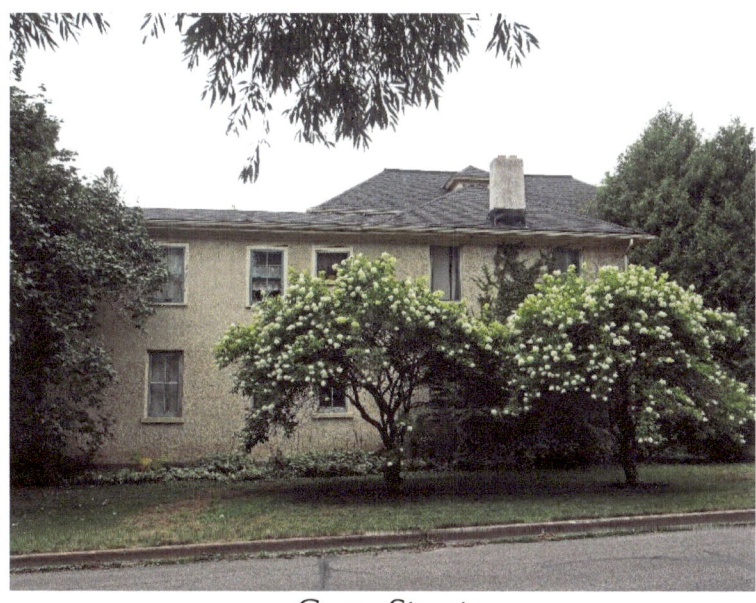

Green Street

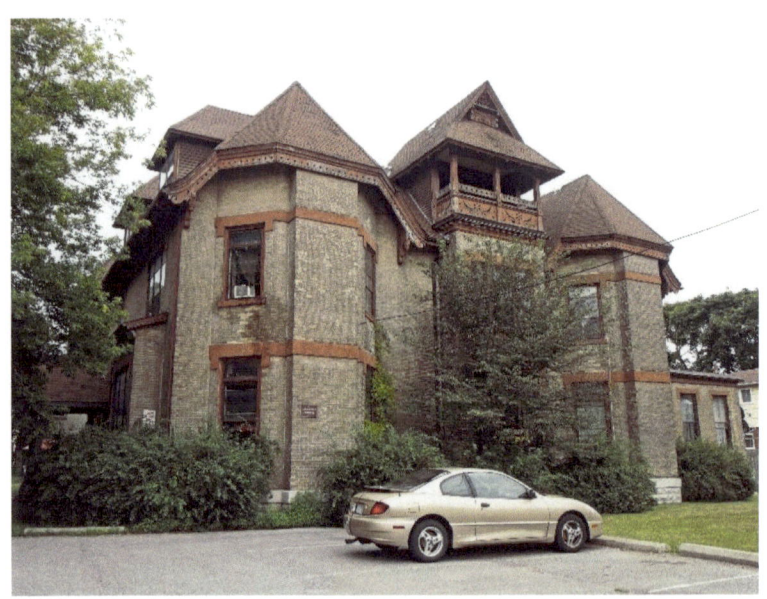

202 Green Street – Hatfield Hall – 1879 – High Victorian Gothic – It was built by retired Civil War Colonel Chambliss, Managing Director of the Cobourg and Marmora Railway and Mining Company. His heiress wife, Sallie, was the daughter of George K. Schoenberger who largely financed the railroad company. In 1890, Colonel Douglass Cornell of Buffalo bought the house for a summer residence and called it Hadfield Hurst (Hadfield was his wife's maiden name). From 1929 to 1951, it was a girls' private school, Hatfield Hall, named after the house where the future Queen Elizabeth I was confined by her sister Queen Mary I. The windows all have transom lights at the top. On the west façade is a third-floor balcony covered with a hip roof and gable with decorative fretwork.

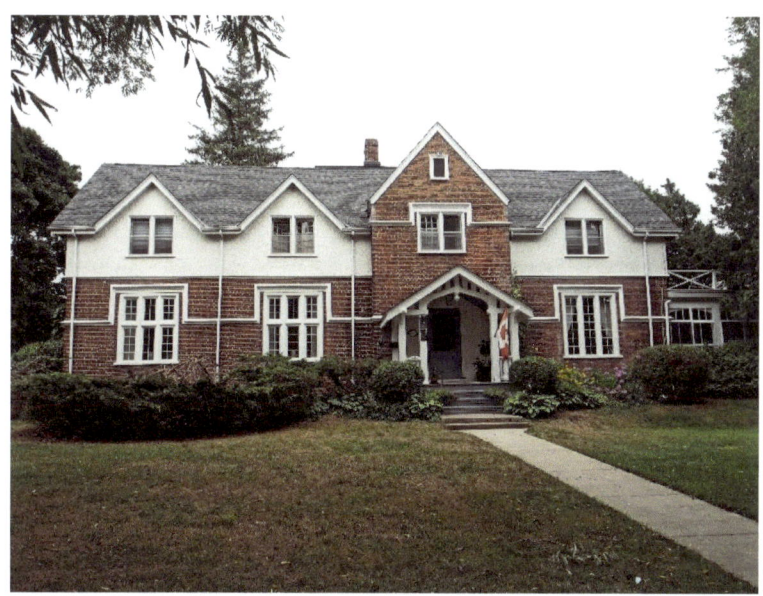

174 Green Street – 1840 – Haskell House was built in the Tudor Gothic style – It was a theological college to train Anglican priests. For many years it was a public school known locally as the Corktown School. In 1906, Mrs. Haskell of Chicago bought it as a summer home and added a second storey and a back wing.

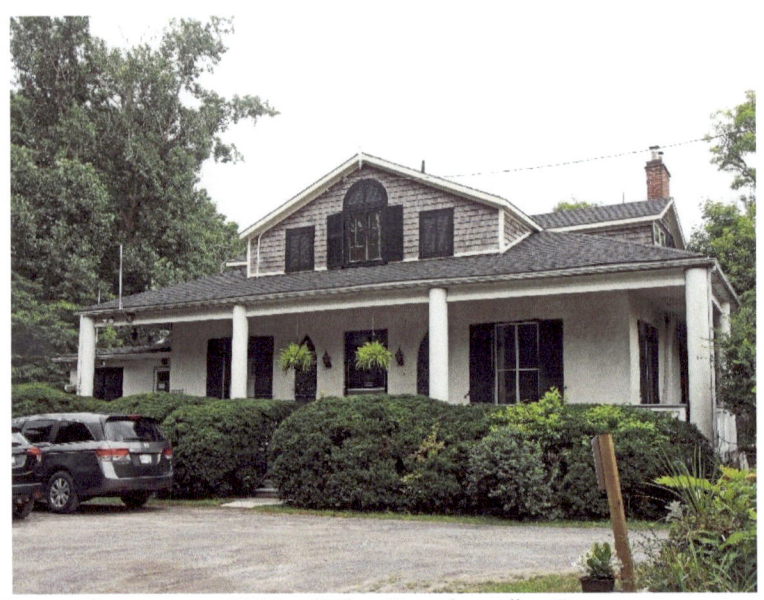

94 Green Street – c. 1850 - "The Breakers" – Regency cottage built by James Calcutt Jr. The roof extends well beyond the walls to provide a shelter for the wraparound veranda. It was called "Cold Blow Cottage" due to its proximity to the lake.

Other Books by Barbara Raue

Coins of Gold
Arrows, Indians and Love
The Life and Times of Barbara
The Cromwell Family Book
Laura Secord Discovered
Daddy Where Are You?

Montana Series
Book 1: Montana Dream
Book 2: Life on the Montana Frontier
Book 3: Montana to Boston and Back
Book 4: Montana Sons Go to War
Book 5: Montana Sons Return from War

Visit Barbara's website to view all of her books
http://barbararaue.ca

© 2019 by Barbara Raue - All the photos in this book have been taken with my cameras. I own the rights to them.